Publisher's Acknowledgements
We would like to thank the following authors and publishers for their kind permission to reprint texts: **Sheryl Conkelton**, Seattle; **Klaus Ottmann**, *Journal of Contemporary Art,* New York. Every effort has been made to secure reprint permissions prior to publication. The publisher apologizes for any inadvertent errors or omissions. If notified, the publisher will endeavour to correct these at the earliest opportunity.

Artist's Acknowledgements
I would like to thank Pamela Lee, Jeremy Gilbert-Rolfe, Matthew Higgs, Sheryl Conkelton and Joan Didion for their thoughtful contributions to this book.
I would also like to thank: Ciléne Andréhn, Tanya Bonakdar, Rena Bransten, Lee Clarke, John Divola, Russell Ferguson, Robert Gunderman, David Horvitz, Robin Hurley, Jim Isermann, Jim Isermann, Geoff Kaplan, Brandon Lattu, Doug Lawing, Chip Leavitt, Timothy Martin, Ron Oesterberg, Andy Ouchi, Marina Schiptjenko, Ethan Skalar, Elizabeth Smith, Rondy Sommer, John Stack, Jan Tumlir, Gilda Williams, Sino Wong, Michael Worthington, Ed Wortz and Amir Zaki.

All works are in private collections unless otherwise stated.

Phaidon Press Limited
Regent's Wharf
All Saints Street
London N1 9PA

Phaidon Press Inc.
180 Varick Street
New York, NY 10014

www.phaidon.com

First published 2004
© 2004 Phaidon Press Limited
All works of Uta Barth are © Uta Barth

ISBN 0 7148 4153 6

A CIP catalogue record of this book is available from the British Library.

Printed in Hong Kong
Designed by Onespace – Ben Dale and Andrew Beattie

cover, front, **... and of time.**
(aot 4) (detail)
2000
Colour photographs
2 parts, 89 × 228.5 cm overall

cover, back, **Ground #57** (detail)
1995
Colour photograph
51 × 59 cm

page 4, **Untitled #8** (detail)
1990
Cel vinyl on black and white photograph
119 × 101.5 cm

page 6, **Uta Barth**
2004

page 34, **Ground #70** (detail)
1996
Colour photograph
41 × 38.5 cm

page 100, **Untitled (98.5)**
(detail)
1998
Colour photographs
3 parts, 96.5 × 501.5 cm overall
Collection Henry Art Gallery, University of Washington, Seattle

page 110, **Ground #77** (detail)
1997
Colour photograph
71 × 88.5 cm

page 144, **Uta Barth**
Photograph by David Horvitz, 2004

Pamela M. Lee Matthew Higgs Jeremy Gilbert-Rolfe

Uta
Barth

Contents

Interview **Matthew Higgs** in conversation with **Uta Barth, page 6.** Survey **Pamela M. Lee**
Uta Barth and the Medium of Perception, **page 34.** Focus **Jeremy Gilbert-Rolfe** Untitled (98.5), **page 100.**
Artist's Choice **Joan Didion** Democracy (extracts), 1984, **page 110.** Artist's
Writings **Uta Barth** Interview with Sheryl Conkelton, 1996, **page 122.** The Colour of Light in Helsinki, 2004,
page 136. Chronology **page 144** & Bibliography, List of Illustrations, **page 159.**

Contents

Interview **Matthew Higgs** in conversation with **Uta Barth, page 6.** Survey Pamela M. Lee

Uta Barth and the Medium of Perception, page 32. Focus Jeremy Gilbert-Rolfe Untitled (98.5), page 96.

Artist's Choice Joan Didion Democracy (extract), 1984, page 106 Artist's

Writings Uta Barth Interview with Sheryl Conkelton, 1996, page 118. On Layout and Design, 1998, page 134 Chronology page 144 & Bibliography, list of illustrations, page 158.

Matthew Higgs A biographical entry in your *In Between Places* catalogue[1] states that while you live and work in California, you remain a German citizen. Why?

Uta Barth **The phrasing in the catalogue is probably a good place to start, as I was rather insistent on it. In American museum publications you're often required to state your nationality, and even though I've lived in the United States since I was twelve years old, I do remain a German citizen, and do so intentionally.**

I grew up in Berlin. My father's a chemist who came to the United States in 1968 to do a research project at Stanford University. Shortly after he moved my mother and me to the United States. I have never lived in Germany again.

Higgs Was that upheaval difficult?

Barth **Well, early adolescence is probably the most difficult age to relocate to a completely different culture.**

Higgs Did you speak English at the time?

Barth **Not really, but at twelve you're incredibly adept at learning new languages. Within about six months I spoke English fluently, but it probably took me a year to feel comfortable. I moved to the States during junior high school, a period when kids can be pretty inhumane. It's an incredibly unpleasant age no matter what, and being from a different country only added to the sense of not fitting in. It was rather overwhelming and alienating.**

Higgs Before you moved to California, were you living in West or East Berlin?

Barth **West Berlin. The wall was still up; I haven't been back to Berlin since it came down.**

Higgs The transition from cold-war West Berlin to 1970s California must have been a culture shock.

Installation views,
'Uta Barth: In Between Places',
Henry Art Gallery, University of
Washington, Seattle, 2000

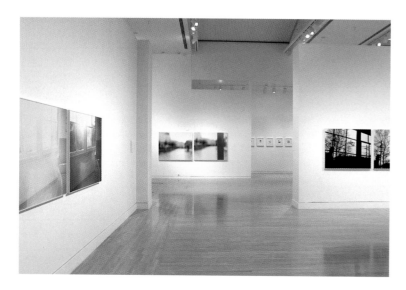

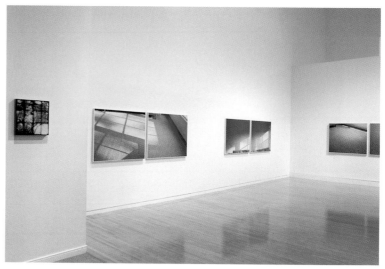

Barth It was very extreme. I was very incapable of identifying with California, or even American culture at large. Yet at the same time my memories of Berlin were pretty dark and austere: post-war Berlin was rather oppressive and dreary. I was very homesick for Europe (and still am) but even at that age, even in the midst of relocating, I knew I never wanted to return to Germany. I'm not sure I particularly liked California either – or at least I did not like the clichéd, carefree California lifestyle of sunny beaches and car culture. All that seemed completely alien to me, and it still does.

Higgs Do the Barth family snapshots from that newly American period look radically different from those of your German childhood?

Barth My family doesn't keep many snapshots, but yes, they are drastically different. Of course this is conveniently exaggerated by the fact that they changed from being in black and white in Germany to colour, once we moved to California. That shift certainly underlines a move from the austere to a … 'California snapshot aesthetic'?

'Austere' is the word that I think I would associate with my memories of Berlin. I've lived in the United States for so long – longer than I ever did in Germany – but I'm acutely aware, when I'm around Americans and particularly those who grew up in California, that I have an entirely different set of cultural references and a different way of seeing the world. This deep difference never ceases to be profoundly apparent to me, even with friends whom I've known for twenty years or more. Growing up in Europe has made me different from my friends here. At the same time, when I go back to Germany, I feel like a tourist.

Higgs Your 2000 exhibition was called 'In Between Places' (Henry Art Gallery, Seattle, and tour). Without wishing to play amateur psychologist, it would seem that the sense of displacement or estrangement you experienced as a child, and continue to negotiate as an adult, is a useful position to sustain, especially in relation to the kind of images you produce, which often seem to describe 'non-places' or places situated at the margins or periphery.

Barth Firstly I should say that I didn't come up with the title for that exhibition

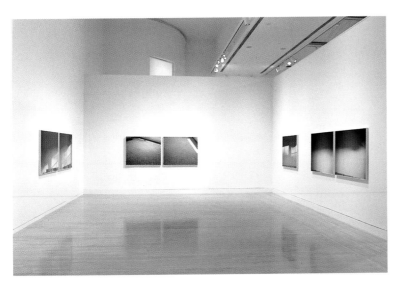
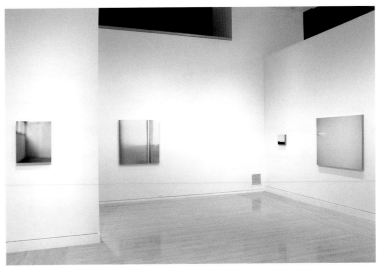

and catalogue. My friend Michael Worthington, who designed the book, did.

Higgs But you agreed to it.

Barth **Yes, I agreed to it, and I like it very much. However, I've never thought of my work in that way. It's never occurred to me, and it's amusing to think about it in that way. What interested me in the title 'In Between Places' is that it evokes a certain kind of detachment that runs through my thinking and through my work. I am interested in the margins, in everything that is peripheral rather than central. But I've never ascribed it to my childhood or sense of dislocation between cultures.**

 I guess displacement, estrangement and detachment are all related.

Higgs Were your parents culturally inclined?

Barth I believe my father was interested in history, in cultural and intellectual history, and obviously, as a chemist, in science. He was interested in cultural artifacts, but he was not interested in art. In fact any discipline that values subjectivity in general and visual art in particular is the antithesis of the standards by which I was raised. I know I got my interest in philosophy and my investment in objectivity from my upbringing. Where the idea of art-making as a practice came from eludes me.

Higgs Perhaps we could talk about a specific work from your *Ground* series, *Ground #42* (1994), which includes two images of paintings by Vermeer.

Barth Obviously they are reproductions. The Vermeer reproductions were the only examples of visual art in the apartment where I grew up in Berlin; I believe they were a wedding present from my father to my mother. When I was four or five years old those images ended up in my bedroom. I spent years and years of my life staring at them, and when my parents eventually separated, I kept them. I think they've been in every house where I've ever lived, in part as a family heirloom, but mostly because they never cease to fascinate me. As an adult, as an artist, I never thought much about Vermeer as an influence. When I started making the *Ground* series, I found myself looking at one of those *Ground* images, and it seemed perversely reminiscent – formally, compositionally – of something I had seen before but just couldn't place. One day I realized that the composition and the quality of light playing in the room was almost identical to one of the Vermeer reproductions.

The overlap or coincidence made a certain sense to me. What I like about Vermeer's work was the investment in the everyday, in the non-event, its departure from the religious allegory of High Renaissance painting. Also, I have always been interested in the quality of light, and how light really is the primary subject of the work. Light and a certain quietness, slowness, stillness. You can hear a pin drop in those paintings.

The *Ground* series literally have no 'event' or subject other than the light that falls on to an environment, so that's sort of where I saw an interesting connection. *Ground #42* actually includes the Vermeer paintings. It seemed an interesting crossing, or reference, but I never thought of Vermeer as a deliberate point of departure.

Higgs Would it be too much to suggest that these images of Vermeer's – with all their autobiographical connotations – that travelled with you from Northern Europe to California, could be understood as a *memento mori* for your childhood in Europe, for your family, for the union of your parents?

Barth Ummm … yes! [*laughs*]. I have a tendency not to want to link things up neatly with this type of psychological interpretation or 20/20 hindsight. I have deep doubts about readings of this sort, about narrative inevitably.

But perhaps … perhaps they are true? I think there's also another, somewhat related aspect to those paintings that I'm attached to, that we can talk about as a 'cultural sensibility', or simply as an art idea. This has to do with attention to the insignificant. They pay attention to the everyday, to the mundane. Time, in the work, is slow. Duration is at play. One does not think of

Ground #42
1994
Colour photograph on panel
28.5 × 26.5 cm
Collection Whitney Museum of
American Art, New York

opposite, **Untitled #1**
1989
Acrylic, black and white
photographs on panels
4 parts, 183 × 305 cm overall

the stereotypical California lifestyle as one that embraces ideas about slowness, or attention to anything other than the spectacle or the event. I can connect with the quietness and attachment to the everyday of Vermeer and see an echo of it in my own work … one could see that as an echo of Europe?

Higgs Could be …

So, tell me about your university studies.

Barth I went to undergraduate school at the University of California at Davis and then went to graduate school at UCLA.

Higgs At Davis, had you already started to think seriously about photography?

Barth I did photography through most of undergraduate school, but I arrived there in a rather indirect way. I remember being in painting and drawing classes at the very beginning of my schooling, and always using photographs as source material. I started to take the photographs I needed to work from, and the paintings and drawings quickly became beside the point. There was no need for the translation into painting and I became interested in the photographs themselves. I made a couple of films, some installation work, and sculpture but ultimately I dealt with all different media and the entire required curriculum, working from photographic source material.

At UCLA I studied in the photography department, but I chose that graduate programme because photography wasn't segregated from other media in the way that it was and still is in other art schools. I wanted to be in a programme where those kinds of distinctions seemed insignificant. I do know the history of photography very well, but none of my influences actually come out of that history. I was much more interested in Minimalism, Structuralism and early Conceptual work. I was looking primarily at sculpture and installation work.

If I have to think about the artists whose work is important to me, I end up going back to people like Robert Irwin rather than the most significant photographers. Most photography draws on a drastically different set of ideas, and most photographs are tied up with pointing at things in the world and thereby ascribing significance to them. These works are about the subjects depicted, or about formal ways of depicting a subject. Ideas about perception and seeing as content in and of itself – ideas that let go of subject, subject matter or ways to depict subject matter – are rarely found in photographic practice. So, while I do have great interest in and respect for historical photographic practice, it has never been the point of departure for my own work.

Higgs I would imagine being interested in Robert Irwin at that time wasn't highly thought of?

Barth It was not hip, no [*laughs*].

Higgs How prominent was the work of, say, Sherrie Levine or Barbara Kruger?

Barth That was exactly the sort of work that was around and being discussed when I was at graduate school. I spent a whole lot of time looking

Robert Irwin
Untitled
1965–67
Acrylic automobile lacquers on
prepared, shaped aluminium with
metal tube, 4 150-watt floodlights
⌀ 152.5 cm, depth 9 cm

Sherrie Levine
Untitled (After Walker Evans No. 3)
1981
Gelatin silver print
25.5 × 20.5 cm

Barbara Kruger
We Are the Objects of Your Suave
Entrapment
1984
Black and white photograph
122 × 231 cm

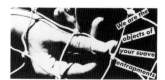

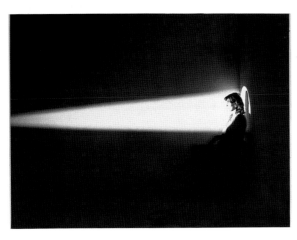
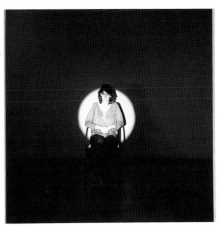

at, reading and thinking about that sort of art, and in many ways I am informed by it.

I was very interested in the analysis of how images make meaning in the world, particularly how images make meaning in relation to each other, in context. Ultimately, however, the politics – at least the overt, didactic, surface politics of the 1980s – were not something that I felt any need to rehash in my own work.

Higgs How did you situate yourself within the then-dominant process of over-theorizing visual culture?

Barth Well, ironically, in graduate school I was probably one of the more articulate and informed students, with regard to the theories in vogue at the time. I remember thinking a lot about discussions on the gaze, and ideas about seeing and being seen, and the power relationships involved in representation. A lot of my early work from graduate school was informed by those discussions.

Higgs Were you making your earliest series of multi-panel works, *Untitled* (1988–89), for example, in which a light beam illuminates a subject, at that time?

Barth Yes. The bodies of work that I started while I was still in graduate school were incredibly self-conscious confrontations with the camera, and were about vision that somehow invades, that is interrogational and confrontational.

The pieces you are referring to, such as *Untitled #1* (1989), dealt with this type of invasive looking and ideas about juxtaposition and malleability of meaning through context. The work later became more and more visceral and more experiential.

With the work from 1988–90 I was primarily interested in the confrontation with the camera, in the physical experience of being looked at, blasted with light, and blinded. I was interested in the physical and psychological discomfort of that. The irony of me being in those images myself is that I am incredibly photo-phobic: ask any of my friends and they will tell you that I am the first to avoid the camera in any social situation. The few snapshots that do exist of me consist of me blocking the camera with my hand. This seems to me either a curiously odd – or a very appropriate? – response for a photographer to have to the camera.

Higgs Are *Untitled* (1988–89) important to you now only as a point of departure, or are there still things in those images that resonate to this day?

Barth *Untitled* (1988–89) was dealing with a lot of things that I'm still interested in, but they had a certain kind of explanatory nature to this work that no longer holds my attention.

Higgs How did you feel your work sat within the West Coast sensibility at that time, around the end of the 1980s–early 1990s? If this had become your surrogate home, did you see the work operating within a West Coast trajectory?

Barth Well, that question sort of assumes the way that we look at West Coast or East Coast identities nowadays. The work that back then was defined as California or West Coast work, from the 1960s, was pretty much ignored when I was a student.

When I was in graduate school, I had very little sense that there was a West Coast aesthetic or sensibility. Los Angeles was not really on the map;

below, **Untitled #8**
1989
Acrylic, black and white
photographs on panels
4 parts, 96.5 × 376 cm overall

opposite, top, **Untitled #14**
1991
Acrylic, black and white
photographs, dyed photographs
on wooden panels
4 parts, 122 × 244 cm overall

everything went through New York, everybody who went to school on the West Coast then went to New York. It was close to impossible for a Los Angeles artist to find gallery representation in town until after they had a gallery in New York. The required validation, to be taken seriously in this town, took place in New York or Europe. In retrospect, we can talk about a group of artists who've all become internationally visible in the last ten or fifteen years, who came out of Los Angeles. We can see how their work differs from what was being made in New York or Europe and how it comes out of a very different set of references, a different type of thinking. Paul Schimmel's 'Helter Skelter: LA Art in the 1990s' at MOCA[2] attempted to identify and articulate those ideas and to some degree embrace the much disliked notion of regionalism. Of course the exhibition was met with a lot of criticism from the local art community, but perhaps, none the less, it was a rather timely idea.

Higgs Perhaps you could say something about the relationship between painting and photography in your work. Certainly in an earlier series of works from 1990, where a photographic image was at the centre of an Op art-like stripe motif, there seemed to be a dialogue or tension between the two media.

Barth **The attachment to painting in that period of my work during 1988–94 was really not in terms of 'painting for painting's sake'. I was interested in juxtaposing photographic images, which are always referential to another place and time, with visual information that was just purely optical.**
 Those pieces such as *Untitled #14* (1990) consist of a field of optical pattern that is so overwhelming that it is virtually impossible for your eyes to focus. And yet you are drawn in to look closer in order to identify the information in the small photographs in the centre of these vibrating fields.

The photographs are voyeuristic views, night-time shots, peering into the windows of suburban houses.

Other images that were juxtaposed with optical patterns were scientific magnifications or interrogation and surveillance images. They all pointed to some type of visual scrutiny, to a visual event as the primary content, and they were placed in such a way as to make seeing them almost impossible. So the use of 'painting' was in part just a way to run visual interference.

Higgs In this period you also started to make decisions about the 'objectness' of the work. With the multi-panel works from 1989, rather than mounting the images traditionally – like photographs – you started to incorporate stretchers. Were you thinking in terms of trying to go beyond the limitations of the actual physical state of a photographic image?

Barth **Some of those decisions were in part very pragmatic. I was trying to level out the presentation physically: the surface of a painted panel to a photographic image. The decisions were about presenting them in the same way. I was making all of these optical paintings (1988–94) which were masked and mechanically done. You can't really talk about them as paintings per se: they're basically painted graphics.**

The multi-panel works (1988–94) were constructed to make the photographic and the painted images equate and be interchangeable. All of the paintings were made with very matt paint. It seemed that the more matt an image was, the more optically confusing it was. The choice of matt-ness had a lot to do with presenting an image in such a way that the eye had nowhere to rest – no shiny surface on which to stop. The opticality of the image becomes even more exaggerated because you don't see the surface, you don't know where to stop and focus. I spent a lot of time trying to figure out how to produce a photographic surface that was similar to this very matt paint. Photographic papers don't have that quality, so I started using a matt surface laminate. The photographic panels needed to butt up to the painted ones, so they were flush mounted on the same type of wooden panel used for

the paintings. These were really just pragmatic decisions about how to juxtapose two things, how to make all the formal qualities interchangeable, so that there would be a seamless transition from one to the next.

There has been a lot of rather ambitious discussion about why my photographs are mounted on wood in order to embrace some similarity with painting, but I am not sure how truly relevant these are to what I was thinking at the time. I am not very sure about any enterprise of making a photograph that would somehow aspire to the look and conditions a painting. This implies a curious hierarchy, of painting as 'higher' art than photography and seems absolutely idiotic to me.

Higgs A transitional point appears in the early 1990s, where this idea of juxtaposition becomes less apparent, or less forceful, or just less interesting to you – the beginning of the *Ground* series. Maybe you could say something about how you approached thinking about the *Ground* series – how this binary relationship of photography to painting is initially less obvious, and how the work then begins to embrace other possibilities, which appear right up until the present day.

Barth **People always see the beginning of the *Ground* series as a very drastic shift. Actually the first images for the *Ground* series appeared in the later multi-panel works (yellow *Untitled* series, 1991–94). But yes, there is a big shift in terms of moving away from thinking about juxtaposition and collision between images, and from being interested primarily in context. I lost interest in the potentially explanatory nature of juxtaposition and became interested in the possibilities of the single image.**

Higgs Your work in the late 1980s was essentially about creating tableaux or situations very much within the framework of the studio, whereas the first series of *Ground* images are exterior places – the outdoors, the beach, the cityscapes, the parks. All of a sudden there's this move away from the dependency on the studio as the frame.

Barth **The images change from being staged or constructed to being made in the world. It seems congruent with a move away from an explanatory mode.**

Higgs Was the *Ground* series the beginning of this shift away from the photographic work as an object that contained its meaning within itself, towards the idea of experientiality on the part of the viewer? The viewer starts to become much more physically, formally implicated beginning with these works.

Barth **I think all of the multi-panel pieces (1988–94) were trying to elicit a visceral understanding or experience for the viewer through juxtaposition. There is a different type of suspended engagement with the later work. It is not analytical, and somehow embodies an experience of vision in a very different way.**

Higgs What role does ambiguity play in these works?

Barth **The early work is very exacting, tightly crafted and explanatory. Starting with the *Ground* series, my sense of obligation to explain everything just fell away, largely because I had enough of a body of work to lay a foundation for understanding, or provide a point of entry.**

I value confusion, a certain kind of confusion that resolves visual and spatial ambiguity. Yet there are other kinds of confusions or misreadings that the work is vulnerable to, that I am acutely nervous about. The discussion of these photographs, or anything that lacks focus for that matter, as being 'painterly' or pictorialist, drives me crazy. It assumes that a photograph would secretly – or overtly – aspire to the attributes of painting in order to justify itself as an artwork.

I always try to throw a wrench into those type of interpretations by including hyper-sharp images in a series, or embracing purely photographic

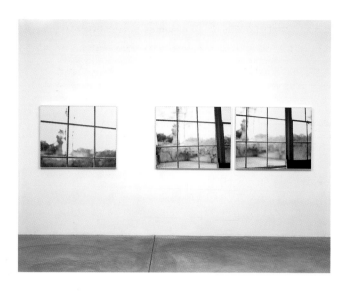

phenomena like lens-flare, things like that. But I'm not sure I always get my point across.

Higgs In 1994 you made an installation of site-specific photographs at the Los Angeles gallery domestic setting. This work seems to have some bearing on more recent images, either of the interior of your own home or looking out through the windows of your home such as *nowhere near* (1999) and *… and of time* (2000). How do you see domestic space in relation to public space?

Barth **My choice of returning to the interior environment in about 1999 was not based on an interest in personal space, or the domestic, or the inside versus the outside. But I see it as a very important moment, when I became very clear about my relationship to photography as a medium. Recent projects in which the camera returns to the inside of a house – the inside of *my* house – are *nowhere near* and *… and of time*, and my most recent series *white blind (bright red)* (2002). There's a very specific set of choices that gets made about location and subject matter, i.e. my own home, in these projects.**

Conventionally we think about the camera as a sort of pointing device. It makes a picture *of* something, for the most part; therefore it is a picture *about* that something. Most of the history of photography is tied up in photographs making meaning in this way. Subject matter, content and meaning are inseparably linked

The inescapable choice one always has to deal with as a photographer is what to point the camera at, and the meaning that this subject matter might suggest. Well, if you are not interested in this type of meaning, if you are not invested in pointing at things in the world but instead are interested in the act of pointing (or looking) itself, you have a big problem. For many years now I have had this very big problem, in fact have invited this problem and have engaged with it in many ways. For these three most recent projects since 1999 my way of dealing with this problem of choice was to make no choice.

I chose to photograph wherever I happened to be, the environment most familiar to me – and that environment was my home. What interests me the

opposite, **nowhere near (nw 10)**
1999
Framed colour photographs
3 parts, 89 × 399 cm overall

below, **nowhere near (nw 9)**
1999
Framed colour photographs
2 parts, 89 × 228.5 cm overall
Collection Lannan Foundation,
Santa Fe

most is that it is so visually familiar that it becomes almost invisible. One moves through one's home without any sense of scrutiny or discovery, almost blindly, navigating it at night, reaching for things without even looking. I am engaged in a different type of looking in this environment. It is truly detached from a focused interest in subject. Instead it provides a sort of ambient visual field. I have no interest in thinking about those projects in terms of domesticity or the home or anything like that.

Higgs That may be, but as a viewer I can't help but think about domesticity when confronted with an image of an interior that's clearly a domestic space. Then I might think about Virginia Woolf's *A Room of One's Own*.[3] I'm sure you're not consciously privileging such things in the work, but there do seem to be signs of internal withdrawal. I can't help thinking about that, especially with images such as *nowhere near*, where you're looking through the window. There's this idea of a longing for what lies beyond.

Barth **People want to read those things into the work, or make those kinds of associations – they make sense to me. And on some level they are accurate or are a subtext of the work. Each series has hundreds of images of the same thing, the same view; so it becomes about time, about duration. And nothing happens, nothing ever changes for days, for months, only the light. It is pretty hard not to interpret this in terms of silence, solitude, contemplation and longing, but that's not what I am thinking.**

My friend Michael (who designed the book for the *nowhere near* series) used to tease me relentlessly by saying that the project was terribly 'sad'. He knew this was exactly the kind of sentimental reading I was fighting against, but at the same time perhaps I was protesting too much.

Still, I do not want this type of narrative to take over. I still place much more value on the thing itself than any interpretation of it. I go to great lengths not to be swallowed up by the anecdotal.

Higgs Despite your use of seriality and the prolific number of images in any series, it still seems that they resist analysis; they resist that idea of the

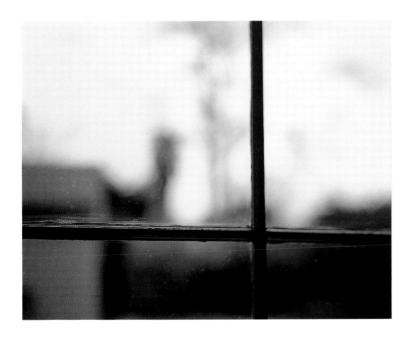

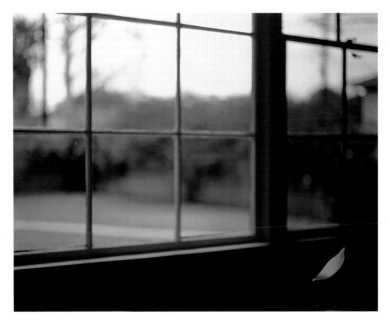

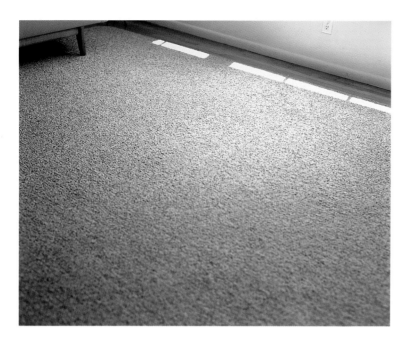

above, **... and of time. (aot 1)**
2000
Colour photographs
2 parts, 89 × 228.5 cm overall

opposite, **... and of time. (aot 4)**
2000
Colour photographs
2 parts, 89 × 228.5 cm overall
Collection J. Paul Getty Museum,
Los Angeles

evidential. One of the things I'm interested in talking to you about regarding the work is boredom; it's in all of the works, especially in the later series, a sense of sort of drifting through the day. The *... and of time* series, for example, seems to deal not just with the question, 'What do I photograph?' but 'Why?' It's almost existential, about a kind of *ennui*, and the fact that it's located in the domestic environment seems significant. These later photographs seem to be confronting head-on the idea of an internalized struggle, or trying to reconcile or just embrace boredom.

Barth **That's a really interesting place to go. I wouldn't think about those ideas in terms of boredom – boredom has a certain kind of pejorative quality – but in terms of an interest ... in this total investment, emersion, in experiencing the non-event, 'boredom' sounds like something you have to escape. I think that the work invests in ideas about time, stillness, inactivity and non-event, not as something threatening or numbing, but as something actually to be embraced. There is a certain desire to embrace that which is completely incidental, peripheral, atmospheric and totally unhinged.**

Higgs Have you increasingly allowed yourself a greater degree of licence to embrace the possibility of emotional subjectivity?

Barth **[*laughs*] ... Well, I'm not so sure about 'emotional' subjectivity ... but, yes. I no longer feel the obligation to answer to an imaginary audience. I have the history of my own work to provide the background information. I mean, I work in the context of my own practice. Previous projects lay the groundwork for how to see my current projects, and that frees up a whole lot of space. I no longer need to address broader ideas; things are getting more and more focused on specific experiences and states of mind.**

Higgs How did working on the retrospective at the Henry Art Gallery in Seattle in 2001 affect you? Where does it leave you now in terms of moving forward?

You've mentioned experiencing a certain kind of 'trauma' with that exhibition.

Barth [*laughs*] **Well, on a pragmatic level, doing a survey show of your own work is incredibly time-consuming and bureaucratic! It's like doing your taxes, you know, sorting your past, your records, your receipts.**

The great part of doing a retrospective is being able physically to see connections that between bodies of work I had not been aware of. Suddenly all these objects, most of which I had not seen in years were assembled in room after room, and I could find unexpected links – not the obvious ones, but seemingly random choices of imagery that repeat over the years. I saw some quality that is an absolutely irrelevant aspect in one body of work emerge as a main theme in the next, and I had never noticed it before. Suddenly I got to see connections in a very different way than I had remembered them.

What's difficult is that a retrospective implies some kind of closure. As an artist I'm always working on two or three things at once; they overlap. You come to the end of one project, and there's some kind of quandary as to where to go next, but I am always working on two other things at the same time. Exhibitions want to tie things up in very neat chapters, but this is like closing a book at a random point. I found myself exhausted and at loose ends the morning after.

Higgs But even if the sense of closure is artificial, you do work in series. Those series have semi-narrative titles – *Ground*, *Field*, *nowhere near* – and even if the end of one series is the point where another begins, creating ambiguous crossover moments, closure is part of the work. It seems to me that the sense of closure that's ambiguous for you becomes formalized for the audience in terms of how the work is presented. One of the key things that might define theoretical work of the 1980s is suppression of biography: the idea that the biographical, the anecdotal is somehow incidental to the work, that it's unnecessary – in fact, that it's a hindrance. Inadvertently, what seems to have

... and of time. (aot 2)
2000
Colour photographs
2 parts, 89 × 228.5 cm overall
Collection Albright-Knox Art
Gallery, Buffalo

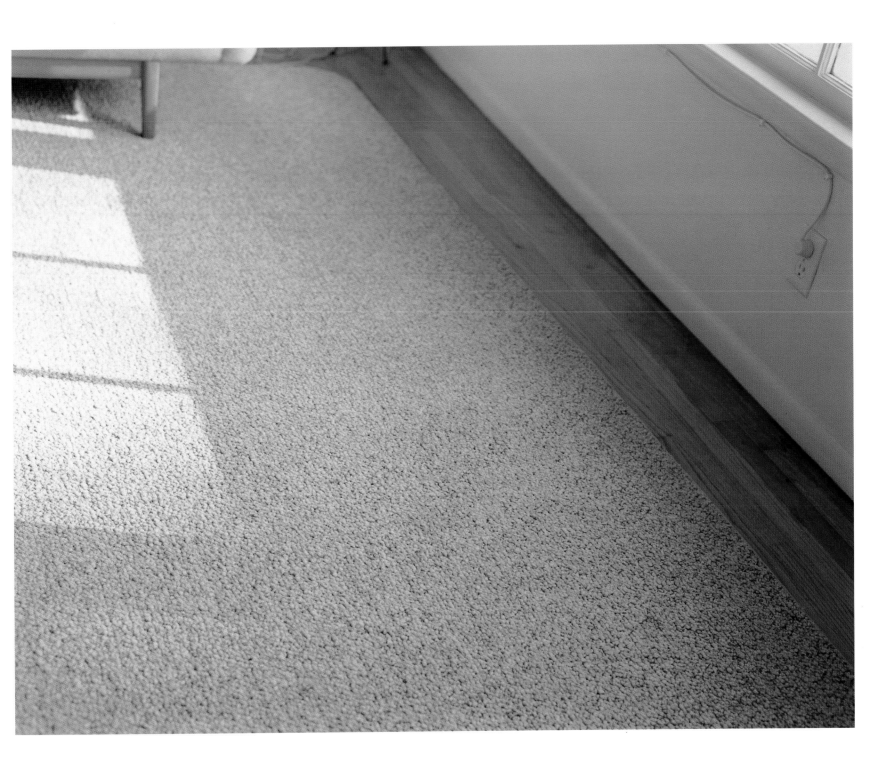

occurred in your very recent work is that, because those works are located
within your domestic environment, the biographical, the anecdotal becomes a
significant factor.

Barth **I think that's true, but I'm still committed to the notion of remaining
anonymous. I am uncomfortable with reading the interior in the most recent
work as a metaphor. The very notion of looking at work in terms of metaphor
runs deeply counter to what I'm interested in. Decoding and metaphors are
ways of reading and interpreting the work, rather than simply looking –
detached from narrative, detached from history, detached from identity. I'm
interested in detachment and anonymity; I'm interested in eliciting a
perceptual experience. Within this process of being interviewed, or doing this
book, I keep finding ways of squirming around personal and autobiographical
information. I don't think I am doing it out of secrecy, I just don't see how it
can be relevant. I am much more interested in pointing towards a perceptual
experience, and allowing that experience to be very different for different
people. My personal parameters would only interfere.**

Higgs I was interested in the body of work of 1998 that you've come to call
Untitled [*laughs*], which is the first manifestation of that term I'd seen in your
work. Was there something inherent in those photographs, for example,
because you were photographing in a different way, you were carrying the
camera with you everywhere and that made it impossible for them to be given a
serial number or title?

Barth **That work was very much about peripheral vision, about visual
incidents that one notices when moving through a space while motivated
by other interests.**

Higgs But your titles then changed significantly, like *Field* and *Ground* where
there's clearly this allusion to painting – the Greenbergian ideas of painting –
to these quasi-poetic titles, such as *nowhere near*, and they're all preceded by

opposite, **Untitled (98.2)**
1998
Colour photographs
2 parts, 114.5 × 297 cm overall
Collection, Metropolitan Museum
of Art, New York

below, **Untitled (99.1)**
1999
Colour photographs
2 parts, 77 × 202 cm overall

Untitled (98.1)
1998
Colour photographs
2 parts, 104 × 268 cm overall
Collection Museum of
Contemporary Art, Miami

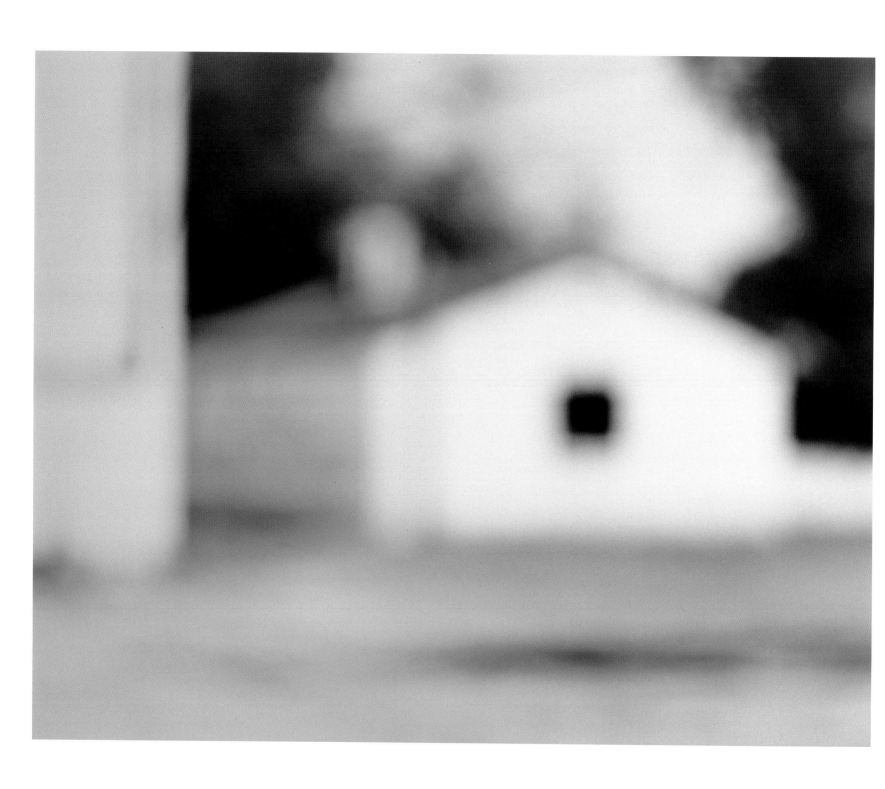

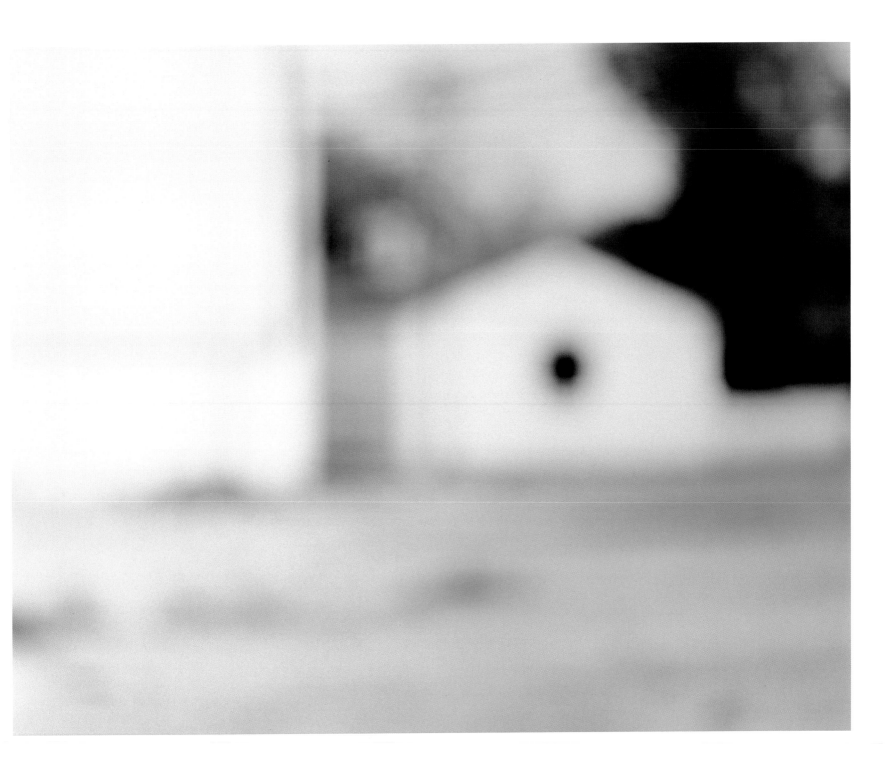

three full-stop punctuation marks, which indicate beforeness, or an idea of a continuation or a fragment. It's a gift to an art historian who's been asked to write about your work, because through the titles you've set them the benchmark from which to go forward or backwards.

white blind (bright red)
2002
Mounted photographs
14 parts, each panel, 54 × 66.5 cm

Barth I think when I titled the *Ground* series and the *Field* series I wasn't thinking about them so literally, as figure/ground relationship or colour field painting. They were also allusions to phrases like 'field of vision', things like that. They didn't seem quite as solid or literal to me then as I think they do now.

With the last three or four projects the notion of time becomes really important, and so the titles are fragments of a larger sentence, as if lifted out of the narrative. Just the notion of the titles being fragments seems similar to the images being 'outside the frame'.

A friend of mine likes to refer to them as 'drifty' titles.

Higgs What are you working on now?

Barth [*laughs*] *white blind (bright red)*. It's just the tree outside of my window! It's no longer even the window; it's just the tree. This in a way returns to my earlier interests, about imagery that the human eye sees differently than the camera lens. There is much attention to the optical phenomena produced by this sustained, prolonged, singular kind of looking. There is a type of optical fatigue, visual fatigue, and a sense of duration that I'm trying to figure out how to present. I am interested in optical after-images and in blinding overexposure.

The context of the house disappears, the window disappears, and again, it's just the tree – the tree outside my window, the most evident visual thing in my life each day. It's just the most evident thing in my life, and it's there.

1 *Uta Barth: In Between Places,* cat., Henry Art Gallery, Seattle, 2001.

2 'Helter Skelter: LA Art in the 1990s' was shown at the Museum of Contemporary Art, Los Angeles, in 1992. The artists in the exhibition were: Chris Burden, Meg Cranston, Victor Estrada, Llyn Foulkes, Richard Jackson, Mike Kelly, Liz Warner, Paul McCarthy, Manuel Ocampo, Raymond Pettibon, Lari Pittman, Charles Ray, Nancy Rubins, Jim Shaw, Megan Williams and Robert Williams.

3 Virginia Woolf, *A Room of One's Own* (1929), Hogarth Press, London, 1930.

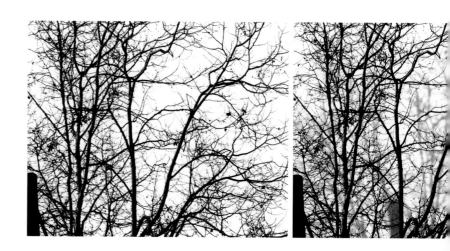

white blind (bright red)
2002
Mounted photographs
14 parts, each panel, 54 × 66.5 cm

Contents

Interview Matthew Higgs in conversation with Uta Barth, page 6.

Survey Pamela M. Lee

Uta Barth and the Medium of Perception, **page 34.** Focus Jeremy Gilbert-Rolfe *Untitled (98.5)* page 100.

Artist's Choice Joan Didion *Democracy* (extract) 1984 page 110. Artist's

Writings Uta Barth interview with Sheryl Conkelton 1996 page 122. *The colour of happiness* 2001 page 136. Chronology page 144 & Bibliography, List of Illustrations page 159.

'The perceiving body does not successively occupy different points of view beneath the gaze of some unlocated consciousness which is thinking about them. For it is reflection which objectifies points of view or perspectives, whereas when I perceive, I belong, through my point of view, to the world as a whole, nor am I even aware of the limits of my visual field. The variety of points of view is hinted at only by an imperceptible shift, a certain 'blurred' effect in the appearance.'[1]

– Maurice Merleau-Ponty

'The question for me always is how can I make you aware of your own activity of looking, instead of losing your attention to thoughts about what it is that you are looking at.'[2]

– Uta Barth

Since the early 1990s, Uta Barth has been making an art of and about perception: a sustained polemic on the mechanics of vision and attention; the vicissitudes of perspective and duration; and the endless intertwining of the phenomenal world and the diversity of its subjects. Unerring in its formal nuance and programmatic rigour, Barth's photography has seemingly internalized Merleau-Ponty's dictum that 'when I perceive, I belong, through my point of view, to the world as a whole, nor am I even aware of the limits of my visual field'. Barth enlarges the scope of this visual field to accommodate the most ephemeral, and thus imperceptible, accidents of the everyday world. To take measure of that world and its accidents – the smudge of a reflection as it drifts across a carpet; the turn of a stoplight caught by peripheral vision; the fillip of leaves by the wind – is to affirm Barth's slow, decisive parsing of perception through the encounter staged between her photographs and the beholder imagined before it.

However attentive to the manifold dimensions of camera vision, Barth does not identify her practice as exclusively photographic. We might say, rather, that her apparatus is not only the camera and its endless list of attendant props, nor just the medium of photography, but perception itself. Perception, of course, is hardly a new topic in the literature on Barth's work. The canniest observers

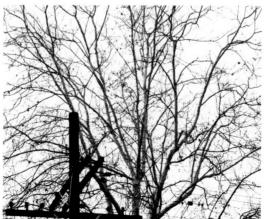

of her art – Jan Tumlir, Timothy Martin and Russell Ferguson, among others – have extensively taken up the question of perception in her work through recourse to the phenomenological turn. Yet the citation that opened this survey suggests something very particular about Barth's commitments. When Merleau-Ponty writes 'nor am I even aware of the limits of my visual field' he inadvertently addresses not only the field of vision, not only vision as it is embedded in the body, but something of the limitations of the visual sense alone as a way to grasp fully 'the world as a whole'. It is precisely an acknowledgement of those limitations – perhaps better put, contingencies – that animates Barth's practice. Her work is as much about the *failures* of vision as it is about its seeming transparency and consolidation; as much about its fallout as the faith we place in its mechanics. Exploring the conditional nature of visual perception, her photography, by turns, has implicated the sensorial tropes attached to sculpture, painting, architecture, film and even music. Barth mines the associations of a variety of media in tracking their respective constructions of perception; and she does so to stress the deeply precarious nature of our perceptual habits.

Take, for instance, one of her most recent works, a suite of grouped photographs from 2002. *white blind (bright red)* pictures the tangled profile of trees, leafless and flattened against a blankly drawn sky, organized into very deliberate sequences ranging from two to six images to a cluster. The occasional figure of a telephone pole is interspersed among the irregular rhythm of the arboreal tracery: upright and unbending, it serves to pace the series temporally, as do the telephone lines extending laterally from it. Here and there one glimpses the silhouette of a bird perched among the branches, while hints of colour seep in against photographic fields largely rendered in black, white and grey. The prints comprising each group are then secured in matt Plexiglas, their surfaces slightly veiled. Standing in contrast to those pictures are brightly coloured panels – a primary red, ox-blood, a dark yellow – that interrupt the visual syntax produced by the repetitive imagery.

The series balances whole and parts against one another, and the implied movement from one work to the next suggests what one critic called 'a flickering of visual consciousness'.[3] When the work was first shown in Los Angeles, the viewer was struck less by the singularity of a particular image than by the totality of the installation, which wrapped around the walls of the gallery in a semi-continuous band. Here was a horizon of images that, like the panoramas of old, enveloped the beholder in a kind of visual drone, its repetition now and again punctuated by the coloured reliefs.

white blind (bright red)
2002
Mounted photographs
14 parts, each panel, 54 × 66.5 cm

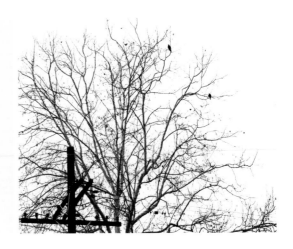

As the auditory reference suggests, Barth was working beyond human or even camera vision, dramatizing something about the interconnectedness of our perceptual machinery, the way in which our eyes, ears and bodies work in tandem in calibrating the sense data streaming within. Indeed the series reflects upon the aporias of vision as announced by the strange optical phantoms that emerge when scanning the images in succession. Real or imagined, the optical tricks that Barth's work seems to elicit correspond to, and are multiplied by, the acute sequencing of the works themselves and the beholder's corresponding movement throughout the space.

The work *white blind (bright red)* will be revisited at the conclusion of this essay, for in its distinct temporal pacing – its passages of slowness and acceleration – coupled with what we would call its virtual *decomposition* of vision, it represents both the logical end point of Barth's concerns and their foundation. To get there, however, demands an approach to the artist's work as steady and systematic as her art: a tracking of the medium of perception as it courses throughout her practice.

Early Work

Born in Berlin, Barth moved with her family to California when she was twelve years old. She studied art as an undergraduate at the University of California Davis before moving to LA to pursue a Master's degree at the University of California there. Though working with photography from the beginning, Barth has described her attraction to UCLA's graduate programme in revealing terms.

She remarks that she ' chose that graduate programme because photography wasn't segregated from other media in the way that it was and still is in other art schools'.[4] Barth's comments showcase her engagement with the diversity of visual media, if anchored fundamentally by, and in dialogue with, photography and its various histories. Yet her interest in art outside the strict classifications of photographic history – Minimalism and Conceptual art mostly – would figure prominently in the way in which she would conceive of her photographic practice relative to the logic of perception.

An early body of works made just after graduate school – black-and-white, multi-panel photographic and painted sequences mounted on wood – introduced the issues that would become central to the range of her investigations. Exhibited at the Los Angeles County Museum of Art in 1989, they take up what one might call the psychodynamics of vision: the peculiar, asymmetric economy that obtains between looker and looked at. Here Barth set up stark, indeed, highly theatrical, scenarios in which she photographed herself under the harsh glare of a beam of light. The klieg-like spotlight stood in as a kind of surrogate camera eye; and the resulting photographs conveyed something of the invasive nature of vision – both photographic and biological – represented by a figure virtually pinned against a dark wall. Alongside photographs of this sort, Barth juxtaposed both found and made images of eyes; helicopters training their search-lights on darkened neighbourhoods (an event familiar to many Angelenos); and solar

eclipses. These images, in turn, were grouped with paintings that recalled the dizzying, even psychedelic patterns of Op art or diagrams drawn from books about optics, light and human vision.

Although Barth subsequently abandoned the multi-panelled format, the works nevertheless posit a set of formal relations that would continue throughout her practice. A wilful disregard for narrative – that is, for the viewer's capacity to conjure narrative out of a series of linked motifs – is reinforced through several devices. The use of repetition, for one, is pronounced. Images are recycled throughout the series: one panel in one grouping might migrate to, and be combined with, images from another sequence. Additionally, a virtual repetition occurs in making the forms of each sequence rhyme with one another; natural phenomena such as a solar eclipse mime the appearance of the eye. The effect that these images produce in combination with one another is consistent with some of Barth's later works. That some of the photographs have the air of an interrogation – as if a prisoner were being grilled by a nameless and all-powerful authority – was to the point. Barth explained the works in terms of 'the confrontation with the camera, in the feeling of being looked at, blasted with light, being blinded, all as a physical experience.'[5] Combined with the optical panels (the viewing of which produces a deeply physical response in the viewer), the works equate a certain psychological and physical violence with the mechanisms of spectatorship, whether produced in the act of 'shooting' pictures or staring at a particular object. Barth would continue her investigation of such

issues in works made not long afterwards. With *Untitled #11–14* (1990) four tiny photographs of a house shot at night are dwarfed by disproportionately large fields painted in black-and-white stripes. The view of the house has been described in terms of the menacing presence of surveillance; and the acrylic stripes framing the image produce not only strong optical vibration in the viewer's eye but a dizzying response in the spectator's body.

Descriptions of these works seem to dovetail perfectly with the reigning critical sensibilities of that moment. Barth's investment in the implicit power relations attached to the photographic act recall art-critical discourses on vision and 'the gaze', as well as important work coming out of film theory. Most prominently theorized in feminist circles, and often deeply inflected by the methods of Lacanian psychoanalysis, such readings supported and elaborated the work of a number of major artists of the 1980s, including Cindy Sherman, Barbara Kruger and Sherrie Levine. Commonly grouped under the rubric of the 'Pictures generation', after an exhibition held in 1978, these artists were acclaimed for their incisive explorations of photographic media and the role that the photograph played in the logic of Spectacle and popular consumption.[6] Although Barth's recourse to found imagery seems to locate this series squarely within the strategies of appropriation emblematic of the period, she was less interested in the social implications of these issues than in the more general structural mechanics of vision.[7]

Indeed the works that immediately followed represented a deliberate attempt to counter what Barth saw as the potentially confrontational tone of that series, and were also meant to dispel any consolidation of a signature style. One of these pieces will be discussed later, following consideration of another group of images that fed directly into the artist's more mature work. Here, Barth clustered together multiple panels that were both painted and photographed, notably interweaving fields of colour into her previously stark black-and-white compositions. Found photographs of a trite nature – pastoral scenes of autumnal trees or dewy images of butterflies – were paired with panels covered with a super matt cell vinyl paint. Barth also introduced language into the equation: isolated words found their way on to some of the panels, themselves painted an eye-popping yellow.

While the format of this body of work recalls the earlier series compositionally, it overturns the thematic of violence underwriting them. In contrast to the black-and-white work, not to mention much of the critical writing around art-making at that time, Barth intentionally embraced the act of looking and the possibilities of aesthetic pleasure, even as the source material she drew upon was deeply clichéd. Arguably, it is precisely because that imagery is so hackneyed that the viewer dispenses with reading the pictures for content or subject matter, instead bringing their attention to looking itself. To such ends the language that Barth used in the panels, such as the word 'at', provided a kind of critical shorthand to the viewing process, as in the implied directive of 'looking at' a painting. The word 'at' makes two

Untitled #16
1990
Photograph and ink on panel
244 × 244 cm

Untitled #13
1991
Acrylic and photographs on wood
panels
4 parts, 122 × 249 cm overall
Collection Los Angeles County
Museum of Art

distinctly different appearances in the series. In one grouping, it is scaled so as to be legible from a middle distance; in another, it is rendered so small that the viewer needs to inspect the work from close up in order to decipher the letters hovering above the painted field. The implied movement between different registers of viewing – the bridging of phenomenal distance as an act of spectatorship – would become foundational to subsequent projects.

This work, in other words, deliberately internalized the space between subject and object, in essence performing the conditions of close and far looking that art historians have theorized about relative to spectatorial attention.[8] Virtually activating the space between the viewer and the wall, it calls up the deeply embodied nature of

visual perception: it reminds us of the fact that it is our *bodies* that see as much as our eyes, and that the will brought to acts of visual attention – the self-consciousness of looking – is grounded in subjective experience. The work likewise established, if in inchoate form, one of the formal devices for which the artist is best known. In the group of pictures that displayed the word 'at', Barth also included a photograph of a landscape, its details blurred so as to forestall immediate comprehension of the image. This seemingly inconsequential gesture, which admits to the relative instability of our visual field, would provide the basis for the works that would follow: the *Grounds*.

The *Grounds*

In 1992 Barth began work on the *Grounds*, a body of photographs that garnered intense critical interest. The series consists of some fifty images ranging in scale from the diminutive to the outsized. Barth's material choices represented a decisive departure from the works that proceeded the series. The mixed-media constructions of her earlier projects – the direct confrontations of painted surface and photographic image – were now abandoned for seemingly blank-faced photographs of anonymous scenes. Still, these were hardly documentary or for that matter descriptive photographs in any conventional sense; and by no means did they forego the project of thinking between media – photography, painting, film, even sculpture – in considering the workings of perception more generally. On the one hand, the conditions of displaying the images did not conform to photography's usual presentational mandate: Barth mounted laminated prints on wood boards several inches thick. The flatness typically expected of the photograph was dispensed with, as was, by extension, the faith placed in the medium to communicate information transparently. Rather, the *Grounds* assume the peculiar quality of objects, at once reinforced by the thickness of their slab-like supports and their veiled, scrim-like surfaces. There is a density to these works – both an associative and phenomenal thickness – that is captured in a phrase often used to describe Barth's works: she has referred to such photographs as 'containers of information'.

Paradoxically, given the declared 'informative' status of such objects, one of Barth's ambitions for the *Grounds* rested with the purposeful thwarting of the viewer's expectations. That sense of wilful 'confusion', however, was not intended as a deliberately hostile gesture towards the audience, in keeping with the thematics of visual assault marking her earliest work. Instead, this was an invitation to reflect upon the mechanics of the pictorial image: how it is that images *mean* something relative to the activity of looking. 'The work invites confusion on several levels,' Barth declared in a 1995 interview with Marilu Knode, and ' "meaning" is generated in the process of "sorting things out"'.

'*A certain kind of confusion or questioning is the starting place of confronting much of the work. Certain expectations are unfulfilled; expectations of what a photograph normally depicts, of how we are supposed to read the space of the image, of how a picture normally presents itself on the wall (contained and enclosed by a frame that demarcates the area of interest and separates it from all that surrounds it in the room, etc.)*'[9]

There can be little doubt that the beholder's share of this confusion stemmed from a new device introduced in the series. Barth now deployed a framing technique that dramatized her engagement with vision and the workings of attention that accompany it. She began by shooting generic locations outdoors, 'as if they were the settings for formal portraits'[10] or cinematic backdrops focusing on a subject in the foreground. The gesture that followed represented a radical reversal of the camera's framing apparatus; for the artist would then remove the subject from the visual field, leaving an

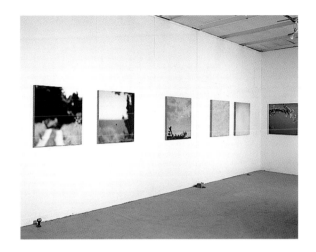

Installation, artist's studio,
l. to r.,
Ground #5
1992
Colour photograph on panel
68.5 × 76 cm
Ground #2
1992–93
Colour photograph on panel
68.5 × 76 cm
Ground #1
1992
Colour photograph on panel
68.5 × 76 cm
Ground #7
1992–93
Colour photograph on panel
68.5 × 76 cm
Ground #8
1992–93
Colour photograph on panel
68.5 × 76 cm
Ground #9
1992–93
Colour photograph on panel
68.5 × 76 cm

unoccupied space in its wake. Repressing the literal subject matter of the camera produced the appearance of a blur in the photograph.

Both the critical reception of the 'blur' and the structural operations it evinces will be considered in due course. Before the complexity of this device can be grasped, however, it is necessary to discuss the evolution of the series itself. The first pictures comprising the *Grounds*, all measuring just shy of the 30 × 40 inch (76 × 101.5 cm) standard format, unfolded, as the artist put it, in 'three chapters',[11] stemming from her work with found imagery. Barth first nodded to vernacular pictures of the landscape, followed by the accoutrements of studio photography, such as the classical vignettes that regularly turn up in prom photos or yearbook pictures. The 'third' chapter took on appropriated imagery that served as the near-invisible backdrops framing our workaday environments: here Barth was interested in the kind of wallpaper murals one might see in the waiting room of a dentist's surgery. The early *Grounds* 'were chosen by seeking out the stereotypical, vernacular, visual vocabulary of what might constitute an ideal scenic or picturesque backdrop'.[12] Barth kept a variety of stock photographic imagery in mind: the backdrops of portrait photography, family snapshots, record cover pictures from the 1960s and 1970s.

By 1994, Barth began training her camera largely on interior spaces. The visual noise

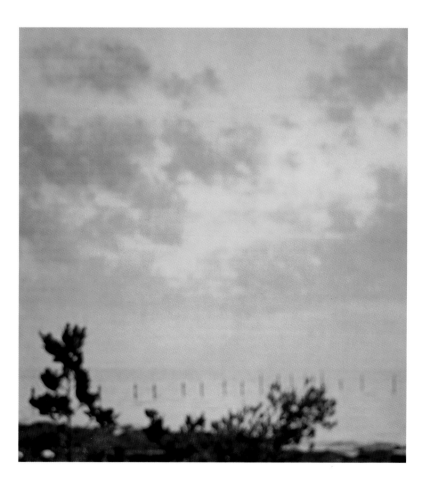 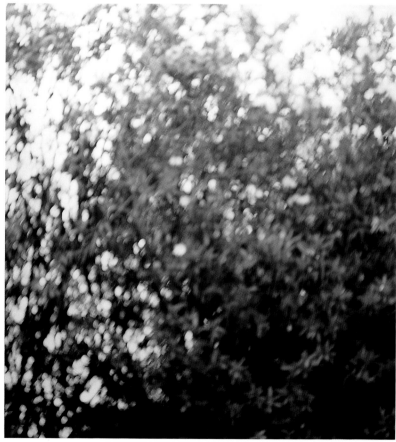

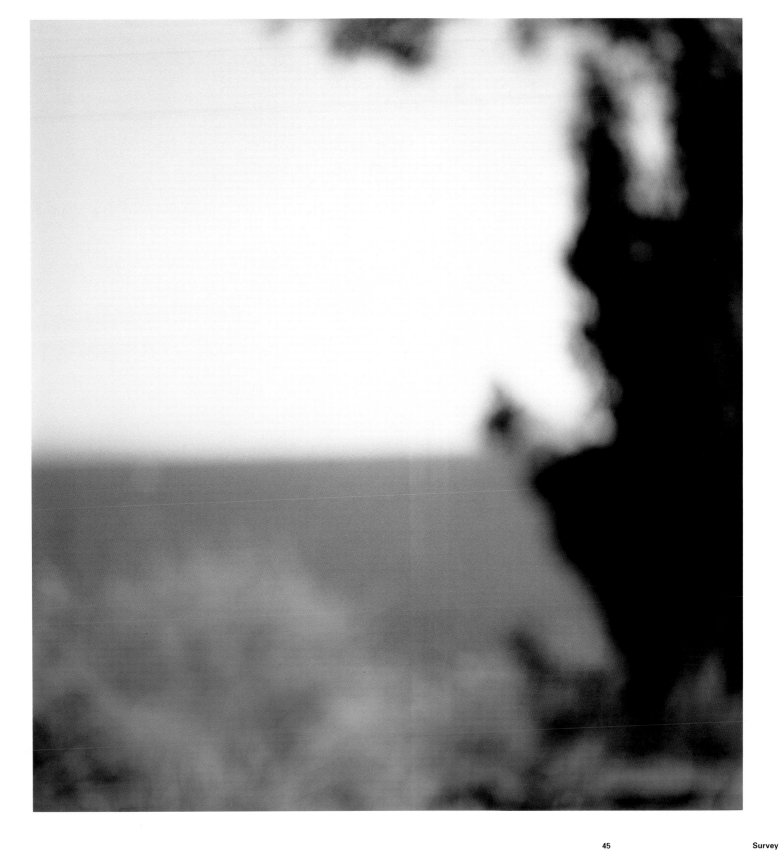

hovering at the margins of each photograph – a curtain, a sliver of window, random accidents of the environment – thus assumed an even more heightened pictorial charge. Indeed, Barth spoke plainly of shifting the viewer's attention to such background information, to the 'types of decisions which are made in every photograph'.[13] Issues of scale, as such, would inform these works to a degree unprecedented in earlier pictures. In articulating how it is that background and foreground interact with one another in the photograph, Barth placed greater emphasis on the operations of framing than before; here was a concentrated effort to move beyond the 'passive framing' situation coextensive with shooting pictures at full frame. The act of cropping assumed considerable importance for this reason. Spending countless hours cropping these images, Barth could calibrate the precise ratio between the implied depth of the photograph with its framing edge.

Very often the results of this process are deeply ambiguous. *Ground #30* (1994) is a vertically oriented photograph awash in shadowy greys and dim white. As representations go, it is patently obscure, yielding little in the way of narrative, description or allegory. Because the picture is devoid of a central focus, the beholder scans at the margins of the image for useful information. Perhaps some adumbration of space is intuited: the concentration of stippled, dark tones at the picture's lower left register – the meeting of vectors forming a strong perpendicular axis – insinuates the corner of a room while

hovering to the extreme left above it, a slightly angled rectangular shape suggests a window, its pale cast registering the passage of light. A work of the same year, *Ground #44,* is likewise evacuated of architectural cues that would provide the image with a sense of *groundedness*. Near the upper-left corner, a yellowish, ovoid shape, swollen at the middle, registers faintly as a Nelson bubble lamp. In the absence of any immediately discernible features – a light pull, the cord connecting the lamp to the ceiling, the *ceiling itself* – the object floats, like a spaceship, with apparently little respect for the laws of architecture or gravity.

Yet identifying the specific features of either picture is beside the point of Barth's endeavour. One notices, for example, that more than a few of the pictures within the series are plain-spoken about the objects represented; *Ground #41*, for instance, is immediately recognized as a bookcase. Apart from the occasional appearance of such transparent images, Barth has claimed that it is less 'what it is that you are looking at' that matters in her work, than attending to the activity of looking. The paradox, though, is that in focusing our attention on the processes of looking, we seize upon the appearance of *distraction* captured in her work. Indeed, the moment the camera eye is deprived of its focus is not unlike the moment of the *Augenblick* – the blink of an eye, a literal shuddering of vision – that illustrates the radical instability of the visual exchange between subject and object. Barth's insistence on foregrounding the act of perceptual attention, rather than the

Ground #3
1992
Colour photograph on panel
81.5 × 73.5 cm

above, l. to r.,
Ground #13
1992–93
Colour photograph on panel
68.5 × 76 cm

Ground #21
1994
Colour photograph on panel
15 × 13.5 cm

object depicted, offers a neat summa for approaching the breadth of her practice.

The viewer's attempts to name the content of the *Grounds*, whether icons of mid-century modernism or the architectural environment, suggest the way in which the will to name and thus objectify things is indivisible from our perceptual habits. Acknowledging the Adamic impulse we entertain before such pictures – our desire to give

order to the world through processes of nomination – coincides with Merleau-Ponty's notion that it is 'reflection which *objectifies* points of view or perspectives', that is, names and thus reifies our perception of the world. Showing up our efforts to make an object out of our point of view, the *Grounds* likewise sets into motion what Barth calls 'the process of sorting things out'.

opposite, **Ground #36**
1994
Colour photograph on panel
43 × 39.5 cm

above, **Ground #78**
1997
Colour photograph on panel
104 × 99 cm
Collections Lannan Foundation,
Santa Fe; Ohio University Museum

below, **Ground #38**
1994
Colour photograph on panel
51 × 51 cm
Collection Whitney Museum of
American Art, New York

opposite, **Ground #45**
1994
Colour photograph on panel
70.5 × 86.5 cm

below, **Ground #44**
1994
Colour photograph on panel
99.5 × 122 cm
Collection Museum of
Contemporary Art, Los Angeles

opposite, **Ground #41**
1994
Colour photograph on panel
28.5 × 26.5 cm

Beyond the 'Aesthetics of the Blur': Of Painting and Sculpture

Not surprisingly, most of the literature on the *Grounds* describes the 'look' of the photographs as a kind of signature style, in essence objectifying Barth's technical devices as stylistic (or even iconographic) motifs. There's no small irony in the observation that, while Barth effectively rids the pictorial field of ostensible content, reception of the work has tended to see (indeed, ontologize) absence as its principal subject matter. More than a few writers on Barth's practice have described this phenomenon in terms of the 'absence of presence' or other such vaguely Derridean formulations, but Barth has been clear about her rejection of this reading and its affective connotations.[14] The term 'absence' brings with it a range of melancholic and nostalgic associations, and Barth has maintained a clear distance from such thematic accounts.

By far the most prevalent tendency in the reading of the *Grounds* is to seize upon what has simply been called 'the blur'. For many, Barth's repressing the object of the camera's focal point results in an aesthetics of the blur, a convenient shorthand that objectifies the epiphenomena of Barth's process, if not the perceptual activity that the process elicits. But when Merleau-Ponty wrote that 'the variety of points of view is hinted at only by an imperceptible shift, a certain 'blurred' effect in the appearance', he was referring to the absolutely conditional nature of perception, the notion that one's point of view was irreducible to the singularity of a totalizing image or perspective, with the appearance of the blur a mere cipher for its irreducibility. Indeed, Barth deliberately

challenged the reading that the *Grounds* were wholly organized around the blur, producing at least one photograph that makes no explicit use of shallow focus. (*Ground #52* pictures a black couch flush against a white wall; the image is unambiguous and crisply rendered.) Instead she has spoken of the visual phenomenon of the blur as the ground for all appearance, its limit condition. 'Blur, or out-of-focusness due to shallow depth of field, is an inherent photographic condition', she notes:

'Actually it is an inherent optical condition that functions in the human eye in exactly the same way as the camera lens. It is part of our everyday vision and perception, yet for the most part we are not aware of it, as our eyes are constantly moving and shifting their point of scrutiny.'[15]

Yet the blurriness of the *Grounds*, as many of Barth's observers have commented, offers a soft-focus view of the world that extends the history of photography's pictorialist imperative: think, for instance, of Alfred Stieglitz's relentlessly formal cloud studies, images that oscillate between silver and shade, or Julia Margaret Cameron's sentimental visions of childhood.[16] In making those comparisons, critics treat 'the blur' as a formal motif that pays homage to an earlier moment. In the process they revisit well-worn debates on the aesthetic and expressive possibilities of the photographic medium.[17]

Such discussions locate the *Grounds* squarely in the history and theory of photography, but reception of the series exceeds that medium. One critic remarked that 'admirers of (Barth's) work tend to skip photographic history and go straight for painting', unintentionally raising issues around choice of medium that Barth's practice decisively considers.[18] No doubt for some observers the blurriness of the works bears a signal relationship to painting: the appearance of out-of-focusness, so the argument goes, approximates the painterly and deeply subjective gesture of the brush. In many respects the literature on Barth follows a larger movement in contemporary criticism that sees much recent art-making – photography, video, new media – in distinct dialogue with the historical legacy of painting, or considers such work 'as painting', as Stephen Melville has cogently argued. A commonplace of art criticism since the 1960s has held that painting is 'dead', a medium long exhausted of both its formal and historical possibilities. But more recent investigations have returned to, if not wholly revivified, the discourse of painting as a means to question both the logic and pervasiveness of the medium in relation to developments in contemporary art.[19]

That the *Grounds* have been insistently described in terms of the language of painting is not surprising in itself, but what is striking is the range of artists and movements to which the works are frequently compared: the Impressionists, Gerhard Richter, Jan Vermeer and the Minimalists have all figured prominently in the treatment of Barth's photography. 'Among contemporary photographers', as one critic put it, 'blur is in, and its use plays with the distinction with painting and photography'.[20] Far from reinforcing the *distinction* between painting and photography, the *Grounds* (and all of Barth's work, for that matter) dwell at

Alfred Stieglitz
Equivalent
1930
Black and white photograph

Julia Margaret Cameron
Annie: My First Success
1864
Black and white photograph

above, **Georges Seurat**
Quai (Gravelines un soir)
1890
Conté crayon on paper
22 × 30 cm

right, **Ground #43**
1994
Colour photograph on panel
26.5 × 28.5 cm
Collection San Francisco Museum
of Modern Art

the intersection between media, as if to comment on the diverse but ultimately *linked* conventions organizing the sensorium through works of art. 'In no way am I interested in making photographs that look like or mimic paintings,' Barth has observed, 'but I am interested in the shared territory between the two, which simply arrives out of established conventions of picture making'.[21]

It's no accident that allusions to the historical movements of Pointillism and Impressionism are legion in the writing on Barth's works. With *Ground #43* an ever-so-slight mottling of tones, producing the faintest division in the pictorial field might recall Seurat's late charcoal studies at Gravelines, drawings in which the relative values of figure and ground are collapsed in the tenebrous

depths of his medium. Barth, though, goes beyond such morphological similarities in proposing an engagement with painting as a medium both structurally informed and then mediated by the history of photography. We know, for instance, that Pointillism was thoroughly saturated with the rhetoric of optics and the claims of the science of perception. Such painting, and the critical discourses that historically supported it, appeal to a distinctly modern type of visuality, coincident with the emergence of photography. Comparing Barth's work to nineteenth-century painting dramatizes the extent to which it necessarily internalized the younger medium, just as the vocabulary of photography was reciprocally informed by the convention.[22] The Pointillist allusions that some identify in Barth's work open on to the logic of perception as it is shot through with the photographic apparatus. Photographic visuality, we could say, is bedrock to modern perception.[23]

The Grounds, in this sense, are paradoxically medium-specific. Steeped in the historiographic and technical traditions of the photograph, they point to ways of seeing operative in adjacent media. They take as a given the historical and conceptual proximity of photography to other forms of art, whether its closeness to painting or sculpture or architecture, and the reliance upon those forms of photography as well. Yet there is one model of painterly vision that trumps all others in the reception of the Grounds; and that is Barth's engagement with the work of Jan Vermeer. The lesson that Vermeer's painting implicitly offers – and its seemingly bizarre connection to the

Minimalist sculpture that Barth also cites as an influence – opens on to the distinct transition between the Grounds and the conceptual and formal preoccupations of work that came after.

At its most obvious, the Grounds share with Vermeer's paintings a remarkably limpid depiction of light. Light in this series takes on a pooled, even melted, appearance that recalls the hushed ambience of Vermeer's canvases: the way in which colours in a tapestry refract like stained glass, or how a morsel of lace appears to glow from within as if incandescent. Barth's particular use of interior space has also been thought to coincide with Vermeer's, both thematically and formally. The space of the home would serve as the starting point for many of her investigations, and the decisive lack of grand narratives in her work – of overwrought activity of any kind – is endemic to Vermeer's quiet imaginings of the domestic sphere. While Barth is explicit about this affinity, she recalls that Vermeer's influence on the Grounds was subliminal. 'Ground #30 (1994)', she recalled, 'seemed oddly familiar to me'.

'After days of wondering about that, I finally realized that the piece reminded me of a particular Vermeer painting. The only artwork in my home as a child was a pair of small Vermeer reproductions, which now hang in my office at the University. I brought them to my studio and found that the layout and composition of the space and the direction and quality of the light in one of those paintings was absolutely identical to the photograph I had just made ... Vermeer seemed a very interesting subtext to this project and I made a photograph (Ground #42) that actually includes the

Ground #40
1994
Black and white photograph on
panel
53.5 × 45.5 cm

two reproductions in the image'.[24]

Ground #42 pays quiet homage to the Northern master. The two framed reproductions of the Vermeers (respectively, the *Milk Maid* and *The Lace Maker*) are marginal actors in her anonymous backdrop, pressed up against the virtual container of the photograph. One is squared neatly with the photograph corner that frames it, the other is positioned a few inches below. The centre of the pictorial field, as in almost all of the *Grounds*, has been purged of visual incident: a monochromatic expanse coloured a milky green absorbs the eye. In the lower left-hand corner an unidentifiable object seems in mute dialogue with the Vermeers across from which it is diagonally set. Far from slavishly reproducing the scenes of Vermeer paintings, in which scrupulous attention to the life of objects is paramount, Barth's photograph projects an air of quietude that bears his unmistakable stamp.

But Barth's comments on the subliminal impact of Vermeer – and the photograph produced out of acknowledging the steady influence of his painting – distil something of her larger concerns for picture making more generally and the visual environment by extension. *Ground #30*, she discovered, identically followed the 'layout and composition of the space' in one of the Vermeer reproductions hung in her childhood home. The photograph sparked by this recognition dramatizes Vermeer's use of space to the point of abstraction. A few rectilinear forms are positioned as if on an implied grid.

There is far more animating this connection, however. Vermeer's own enterprise, as recent scholarship has been wont to demonstrate, may itself have been organized around a proto-photographic practice, one that by necessity sutured the space outside the image's frame *into* the illusionistic depths of the painting. Philip Steadman has recently speculated on the use of the camera obscura in the production of Vermeer's interiors.[25] He argues that the composition of Vermeer's work makes material the spatial coordinates of the camera obscura or 'dark room': the primitive chamber that is the basis of modern photography. The technology of photographic space, in other words, undergrids the spatial template for Vermeer's art as a painter. The introduction of 'lived' space into the representational space of the picture plane finds its mediation in the camera obscura. And it is our awareness of this technical device that establishes our reading of the painting as much *outside* its framing edge as the interior space depicted within it.

In an analogous fashion the *Grounds* internalize the structural apparatus of the camera as manifested in the blurred space of each image's foreground. What is often described as the 'blur' or as 'out-of-focus' in the *Grounds* does, in fact, remain focused in the camera's eye; it is only because our attention is drawn to the implied background of the image, habituated as we are to seeing in terms of traditional figure/ground relations, that we notice the appearance of this effect in front of us. A literal account of this appearance might suggest that Barth deprives us of a subject, has banished human presence in her work. Not so: on the contrary, she restores presence to her pictures through foregrounding a subject stationed outside its visual field. As

Timothy Martin has described this phenomenon, 'there is no missing subject', arguing instead that Barth's is a gesture of 'bracketing', borrowing from the rhetoric of phenomenology to stake his claim. What appears as an 'absence' of sorts is in actuality a sensorial bracketing – the distillation of the visual sense – that takes place when we narrow our vision on a given object or scene. As a long tradition in the literature on photography would have it, camera eye is contiguous with the eye of the beholder, whether from the point of view of the artist or the beholder imagined before the work of art. Indeed Barth reminds us that 'out-of-focusness due to shallow depth of field is an inherent photographic condition'; it is 'an inherent optical condition that functions in the human eye in exactly the same way as the camera lens'. This remark underscores, as does recognition of Vermeer's use of the camera obscura in the making of his painting, the deeply *relative* values of foreground and background as they shift with the locus of the viewer or artist.

Vermeer's lesson for Barth thus confirms and surpasses both the ambience of his interiors and the modelling of his light. What we commonly think of as the 'intimacy' of Vermeer's spaces, expressed through the small gestures of his figures and the way in which they compel our attention to such details, might also be described as an encounter with our own phenomenological horizon. The *Grounds* dramatize how we *produce* space – background and foreground – in our relationship with objects, even as we imagine ourselves to be passively perceiving or approaching them.

A comparison to more recent art dramatizes the significance that Vermeer may have for Barth's practice in spatial terms. The similarity between some of the *Grounds* and Minimalist painting has not been lost on many of her observers (Robert Ryman has been frequently cited) and this is certainly the case for *Ground #42*, which includes the reproductions of Barth's two cherished Vermeers within it. As so many pictures in the series do, the work teeters on the abstract. Its space is shallow, approaching flatness, and the minimal interruption of objects in the corner of the photograph draws the viewer ineluctably to the work's framing conditions. And yet the *Grounds*, as noted earlier, are not framed as traditional pictures are but mounted on thick

Ground #51
1995
Colour photograph on panel
40.5 × 42.5 cm
Collection Los Angeles Center for
Photographic Studies

supports that bear a distinctly object-like quality. The implied passage from the two-dimensional picture plane to three-dimensional sculpture anticipates Barth's engagement with the actuality of phenomenal space relative to the photographs, and not just the representation of space contained within the image.

Strange as the connection between Barth, Vermeer and Minimalism may seem, it is through Minimalism's acute meditation of how the viewer perceives space through actively constructing it (in short, its phenomenological predilections) that ties the three together. 'Minimal art', Barth observes, 'proposes that a viewer relocates her or his self in relation to the object and its space, or a confusion of subject and object'.[26] Similarities between the *Grounds* and Minimalist art, whether

painting or sculpture, are described not only in terms of their respective lack of subject matter, but, perhaps more importantly, in terms of what the beholder does in response to that lack. In both her own work and Minimalist art, Barth notes that 'the subject is removed and one is left with relating information to the edge'.[27]

A brief demonstration of this logic as it applies to Minimalist sculpture bears upon a reading of Barth's practice. A metal cube placed in a gallery, we observe, stages a different encounter for the beholder from the very same cube stationed outdoors. The installation and lighting of Minimalist sculpture, its scale relative to the environment and its evacuation of content or subject matter all stress the shifting conditions of looking in the perception of objects over the

Ground #53
1995
Colour photograph on panel
39.5 × 47.5 cm

right, **Ground #59**
1995
Colour photograph on panel
30.5 × 26.5 cm

below, **Ground #60**
1995
Colour photograph on panel
26.5 × 30.5 cm
Collection Israel Museum,
Jerusalem

opposite, **Ground #56**
1995
Colour photograph on panel
61 × 77 cm

imagined autonomy of the work of art. Minimalism's violations of medium-specificity – the sense that this work was, to follow Donald Judd's canonical reading, neither wholly painting nor sculpture but something in between – will likewise figure into Barth's photographic work. The systematic way in which Barth mines the associations of a variety of media in tracking their respective constructions of perception has already been discussed, and this position finds its principal articulation in the historical discourses around Minimalism.

Indeed, one point at which Barth's filtering of Vermeer coincided seamlessly with the projections of Minimalism was in an exhibition held at a small Los Angeles gallery called domestic setting. The space was an 'alternative' gallery in west Los Angeles that emerged in the wake of several gallery closures following the economic recession in the late 1980s. Run by Bill Radowick, domestic setting was a house that featured an exhibition space where Barth mounted a two-person show in 1994 with Vikky Alexander. Considered a 'breakthrough' in the artist's trajectory, the show included a number of the photographs previously discussed in this essay, among them, those

featuring the reproductions of Vermeer.

At domestic setting Barth made direct reference to the gallery's space in the production of her photographs, both the representation of that space and its particular role in siting the actual works. It was here that she began her extensive work with interiors.[28] Barth suggested that the gallery's character forced her to rethink the kind of pictures she would display within it, intuiting, somehow, that it would be 'inappropriate' to proceed with the usual installation of her works, as if the house were a 'neutral' gallery setting. In reaction to these conditions, themselves intimate compared to most institutional art environments, Barth

photographed the interior of the gallery and installed the resulting images in direct exchange with the architectural features of the site. The plain geometries represented in each picture make equal nods to both the phenomenal rigour of Minimalist art and the otherwise forgotten spaces of vernacular architecture.

Barth's juxtaposition of 'actual' and 'represented' space was, as Elizabeth Smith described it, a 'strategy (that) allowed (her) to play with the physical relationships between images and architecture, not only in terms of how they corresponded but also as a response to domestic conventions of display'.[29] What the installation acknowledged more broadly, apart

from the novelty of its domestic situation, was how the physical context for these images produced their own framing condition: the framing condition of architecture. Here we must remind ourselves that Minimalism's concern for the siting of objects has been theorized in terms of the exchange between art and architecture, a relationship that by turns was expressed as a function of the play between figure and ground.[30] Effaced of any content or subject matter, Minimalist sculpture took the formal relations of figure and ground *out* of the object and projected them on to the work's phenomenal horizon, with the result that the physical environment was now understood as ground itself. Barth's exhibition at domestic setting can be profitably considered in these terms. The works establish some continuity between the perception of interior space and its external construction, the connection between the two forged by the beholder's approach. As Barth has noted:

'When looking at these very minimal images of white walls and corners, one becomes aware not only of the piece itself, but of the wall surrounding it … In the case of the exhibition at domestic setting, one also realized that the photograph was hanging on the same wall depicted in the image, bringing it full circle.'[31]

Even as Barth took up the literal stage of viewing in producing her work for the show, she also stressed that such work is not dogmatically site-specific. The photographs at domestic setting still remained relatively generic: they communicated nothing in the way of features that explicitly identify the site. However attentive to the concrete materiality of its viewing conditions, the work does not narrate those conditions – and, by extension, does not thematize them as content or subject matter. Barth has periodically made works for a given site (she was commissioned to produce billboard-scaled pieces for the MCA in Chicago, one of which is owned by the Tate Modern, London, as she has for the Wexner Center in Columbus, Ohio), but makes an implicit distinction between such practices and the conceits underwriting much site-specific art.[32]

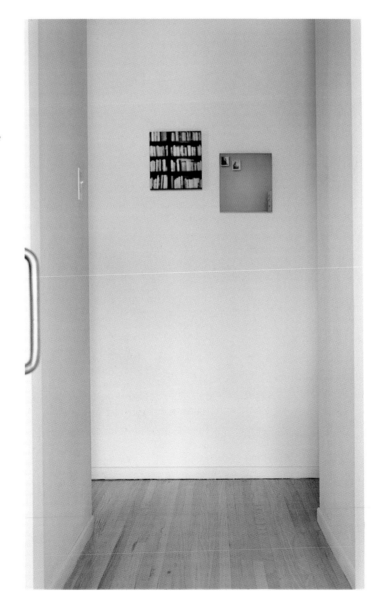

Installation views, 'Uta Barth and Vikky Alexander', domestic setting, Los Angeles, 1994

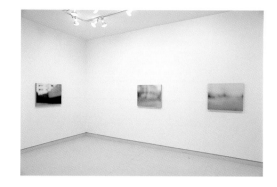

below, **Field #2**
1995
Colour photograph on panel
58.5 × 73 cm

right, installation view,
S.L. Simpson Gallery, Toronto,
1996
l. to r.,
Field #7
1995
Colour photograph on panel
58.5 × 73 cm
Field #15
1996
Colour photograph on panel
58.5 × 73 cm
Field #11
1996
Colour photograph on panel
58.5 × 73 cm

opposite, **Field #17**
1996
Colour photograph on panel
58.5 × 73 cm

Fields and the Cinematographic Apparatus

The works that followed the *Grounds* acknowledged that a photograph's perceived relationship to site corresponds to a subject's peculiar mobility through space. A Minimalist reading of the *Grounds* anticipates what one could call the 'temporalization' of the image in the *Fields* begun in 1995–96. In pictures ranging from rain-soaked street scenes to more bucolic imagery of fluttering leaves Barth shifted focus to the implied movement of a subject at work in the reading

of her photographs. To mobilize the image was to give rise to a new format. If Barth was specifically engaged with figure/ground relationships in earlier series (and the question of peripheral vision attending these relationships as a form of spectatorial attention), here the organization of the image was laterally dispersed. In other words, the works suggested a virtual movement *across* space rather than *into* the imagined depths of the photograph. Rather than decisively cropping the image as she had with the *Grounds*, Barth left the picture at full frame, the scale of the images consistent throughout. In contrast to the vernacular scrapbook imagery that was her touchstone for earlier material, the passive framing condition of the *Fields* evokes the mechanisms of film.

Barth's interest in film – and what film theory has long described in terms of the cinematographic apparatus – was not new in and of itself.[33] In his classic account of the ideological effects of the apparatus, Jean-Louis Baudry argued that '*the meaning effect produced [in film] does not depend only on the content of the images but also on the material procedures by which an image of continuity, dependent on the persistence of vision, is restored from discontinuous elements*'.[34] Barth's work engages such principles in her considerations of the cinematic projection event and the various structural devices – not to mention the cinematic ellipses – that produce the illusion of filmic space and time.

That interest bore precedent in earlier work. In a piece from 1992 Barth produced a grid of

black-and-white prints made from film leaders. Measuring 228.5 × 381 cm, this field of numbers clocking down the seconds embodies the sense of anticipation felt when waiting for a movie to begin. Barth's approach to the question of time in the work of art – how the experience of viewing works of art necessarily incorporates the temporal – finds its explicit demonstration in the time-based medium that is film. With this untitled work, however, Barth eschews the narrative dimensions of conventional film to concentrate on the structural mechanisms shoring up our perception of that medium. Her virtually 'structuralist' parsing of film (and her interest in structural film by extension) would be explored in greater depth with the *Fields* and in subsequent work.

The *Fields* can be described in cinematic terms in a number of ways, not least of which involves production of the images. Barth has likened making the works to 'location scouting', that decidedly LA-based exercise in which producers seek to discover the perfect location for a specific scene in a film. Following in that tradition, which might involve covering great distances to find the most apposite site, some of the works in the series necessarily evoke another activity deeply associative of the Los Angeles environment: driving. The media images that we typically associate with Los Angeles, whether or not explicitly tied to the movie industry, are inflected by the culture of the automobile. Yet rather than presenting us with utopian vistas of relentless sunshine – a top-down view of the city snapped from a convertible – Barth provides pictures that are at once more atmospheric and less literal

descriptions of the place that gave rise to their production.

Consider the pictures taken from the later part of the series, in which Barth's attention to atmosphere and light led her to shoot images over the course of several hours in the rain. On capturing such scenes in the *Fields*, Barth described having 'certain films in mind'. The artist is typically ambiguous about identifying those films through narrative, a point in keeping with her general modus operandi: concerned as she is with evoking the ambience of cinematic space and time rather than actual movies, implied diagesis

opposite, **Field #3**
1995
Colour photograph on panel
58.5 × 73 cm

above, **Untitled**
1992
Black and white photographs
168 parts, 228.5 × 381 cm overall

Field #14
1996
Colour photograph on panel
58.5 × 73 cm

below, **Field #21**
1997
Acrylic lacquer on canvas
335.5 × 518 cm
Collection Museum of Fine Arts,
Houston

opposite, **Field #20**
1995
Acrylic lacquer on canvas
335.5 × 518 cm
Collection Tate Gallery, London

proves irrelevant to her project. A picture of a rainy street is compositionally anchored by a strong vertical – a pole for a traffic light. The street is reduced to aerated patches of soft grey; slightly burnished orange tones in the implied background suggest a horizon marked by architecture. Yet the diffused patches of intense red that one understands to be traffic lights – the first hovering against the pale field of the sky, the second a brilliant orb set flush against the pole – underscore something of the cinematic as well as temporal interests of the series. The traffic light, for one, stands in as a metonym of anticipation –

of the viewer's moving through the representation and the literal stopping and starting that image describes. Lights assume a flickering, indeterminate quality that belies the intense saturation of red that announces them as such objects in the first place. The slightly unstable, even unfocused, representation of the light, begins to read as a cipher of the visual process itself, in which blinking, focusing and glimpsing things as one traverses space finds its material analogue in the movement of the street.

Photographs from another series of untitled works present this perspective by multiplying the

beholder's point of view, isolating what might, in a filmic sequence, run together as seamless or continuous. With these works Barth began exploiting the diptych and triptych format to analyse the mechanics of a visual double take: that moment in passively perceiving the world in which one catches sight of a detail that briefly arrests vision, compelling the beholder to look again. In *Untitled 98.4,* a close-up image of a tree, photographed on a path in Vermont, appears to segue into its paired double – and yet not quite. The slight shift in focus – the flutter of leaves from one picture to the next – betrays something more than a subtle change in scale. (In other pictures from the series Barth would work more explicitly with the shifting visual registers of the zoom or a generalized perspective.) On the one hand, the diptych implicates the workings of binocular vision: the 'doubledness' of visual apparatus. But it also suggests what Gilles Deleuze has described, relative to the mechanisms of classical cinema, as the projection of the 'any-instant-whatever'.[35] Indeed, the two-panelled work highlights the durational lag that takes place not only in the act of making the image (Barth would spend an hour

or even longer shooting one frame to the next) but in the act of attention one brings to it. Russell Ferguson, writing persuasively about this particular piece, makes recourse to Michelangelo Antonioni's classic film *Blow-Up* (1966) to describe a similar dynamic of viewing in the work.[36] Drawn to a disturbing detail in the background of one of his photographs, the anti-hero of Antonioni's movie progressively enlarges the print and in the process unspools a mystery that serves as the movie's narrative thread. The oscillation between generalized looking and close scrutiny of the photographic detail is a response that Barth's work will similarly elicit.

Capturing the double take in this untitled body of work bears certain parallels to the effect of blurring in Barth's earlier series; both devices entreat one to think about the place of one's body in its encounter with the image's projection. In stretching or prolonging this visual act across two or three photographic panels, Barth plays as much with the heterogeneity of duration as she once had with peripheral vision. Several triptychs depicting verdant landscapes veiled in mist strongly address the element of waiting hinted at in the single-

above, **Michelangelo Antonioni**
Blow-Up
1966
111 mins., colour, sound

below, **Untitled (98.6)**
1998
Colour photographs
2 parts, 101.5 × 263 cm overall

panel work. The spacing of these panels, which occur at irregular intervals, suggests both lapses in the viewer's attention and a durational gap that occurs between shooting a sequence of frames. As if to reveal that vision is discontinuous, proceeding by fits and starts, Barth explicitly appeals to the peregrinations of time in her work, a dimension that will assume even greater conceptual and material force.

nowhere near ... and of time
The two bodies of work that followed these photographs – respectively, *nowhere near* and the series ... *and of time* would take up the registration of the temporal in the photographic medium in order to interrogate the vicissitudes of vision more generally. They share an explicit engagement with time, as they do with an inverse relationship to space; the former tracks the movements of the outside as seen from within, the latter plays with the introjection of the external world through its projection.

With *nowhere near* Barth shot pictures almost every day of the project's duration and has

hundreds of negatives to show for it. In contrast to the implied mobility of the viewing subject in the *Fields*, each photograph suggests a static subject: the pictures were repeatedly taken from the same place, a low vantage point inside the artist's house directed through a multi-paned window to a yard. Repeating this point of view for almost an entire year allowed Barth to localize her engagements to visual phenomena, which stood in excess of the humble vista of the artist's backyard. Several readings of the work have stressed the domestic situation as its implicit subtext; and they offer somewhat romantic narratives about the space of women in the home.[37] Barth describes *nowhere near* in far more pragmatic language, however: the work departs from the notion that the mind doesn't actively perceive overly familiar surroundings such as that of the domestic scene. Repetition, then, at once enables the artist to dispense with matters of content as it places further stress on the shifts that occur between individual images in the series.

The project makes use of the serial nature of the photographic medium and exploits its

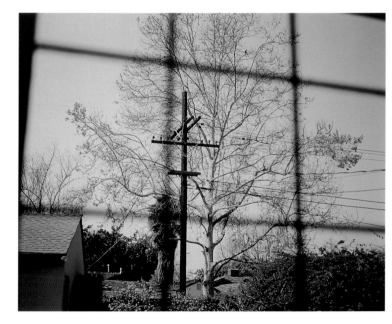

repetition to comment on time. On the one hand, the duration demanded in the making of *nowhere near*, and the still nature of Barth's vantage point, directly appeal to changes in the environment. Shifts in light and the weather serve as an analogue to the seriality of the photographic image: numerous photographs feature rain-spattered windows; others dwell on the intensity or obscurity of light as it is reflected in the glass; a glimpse of a tree or a telephone pole affords a diminished perspective on the outside world. It is in this sense that the pictures might be discussed with regards to photoconceptualism, numerous examples of which were deeply engaged with the systematic exploration of the temporal.[38] The work of Jan Dibbets, among others, functions as logical points of comparison for the series; whereas the experimental cinema of the 1960s – one thinks of the films of Michael Snow – also suggests historical precedents to Barth's serial investigations.

On the other hand, the repetition of such images bears a more pronounced relation to a particular way of seeing than any movement from the history of art: the act of staring. *nowhere near* seemingly works against the model of time established in her untitled photographs, in which the spaces intervening between the multi-panelled work produce an arrhythmic experience of vision – the gaze interrupted by time and lapses of attention, or the halting reaction of the double take. The repetition inherent to *nowhere near*, however, stems in part from the repetition of looking – of occupying the same vantage point for months on end. It upholds a kind of plodding, relentless duration against the discontinuous vision announced by her previous body of work. And yet the long view – and the long *dureé* implied along with it – shares a feature of the cinematographic apparatus with the *Fields*: the notion of a long *take* in which the camera's panoramic sweep is imagined to embody omniscient vision.

Barth, though, inverts this model to the extent that vision in *nowhere near* – and camera vision by extension – is subject to failure. Committed as Barth's act of staring may be, in this instance vision is understood as precarious, as

nowhere near (nw 1)
1999
Colour photographs
2 parts, 89 × 228.5 cm overall

nowhere near (nw 12)
1999
Colour photograph
89 × 112 cm
Collection Lannan Foundation,
Santa Fe

detailed by the seemingly endless proliferation of photographic 'mistakes' that the work wilfully embraces. From lens flare to blow out to overexposure, *nowhere near* reads as a primer in how *not* to take a photograph. It aggressively courts all the errors that nascent photographers attempt strenuously to avoid: in a diptych from 1999 a lens flare mimes the structure of a solar flash. This circular form – a cipher for the eye – appears superimposed on the grid-like window of the pictorial surface, yet another emblem of visual insight compromised by the camera's inability to accommodate the accidents of light. Far from consolidating omniscient vision, then, the long, dead-pan stare is indicted as the point at which vision begins to collapse; and the alleged capacity of camera vision to exceed the failings of human sight is similarly indicted. Just how and in what ways that collapse takes form, though, is described through a range of imagery surprising for the narrowness of its subject matter. *nowhere near* debuted at three galleries simultaneously; and each show's respective iterations suggest manifold difference within repetition, as the 'event' of light passing through a window opens on to ever more specific micro-events.

Around the same time that Barth was making *nowhere near* she was also creating a complementary series, the elliptically named ... *and of time*. *nowhere near* trained its gaze on the movement of light falling through a window: although shot from inside the home, camera vision was turned outwards, giving fleeting form to the influence of the external world. Critics have commented on the use of the window in the series

as a kind of meta-representation of sight – both human vision and camera vision – drawing on the Albertian implications of perspective systems suggested by the framing of the image. These principles are reversed in ... *and of time*, through inverting the world outside the room into a projection within it, much as if we inhabited the space of a camera obscura whose representations are normally viewed from the inside out. The virtual shift implied between inside and out, between the privacy of the home and the openness of the outside attests to Barth's larger inquiry into the permeability of both spheres.

In a number of images from ... *and of time* the gridded reflection of the same windows featured in *nowhere near* appears slightly warped, as if sucked through a temporal vortex. A diptych focuses on a reflection hanging like a picture above a couch. The strict geometry of the window as a framing device has itself been subjected to the very conditions it sets up in *nowhere near*; the reflection of those windows in the interior space of the home, now floating and distended, is offered in sharp contrast to the hard, repetitive forms of the furniture below it. Tracking the movement of those windows elsewhere within the house, Barth turns the camera to the floor. The strange point of view enables her to chart the slow movement of that frame drifting across a carpet, highlighting the peculiar form duration assumes as it meets up with architecture. Timothy Martin sums up the elusive structure of temporality well in these works when he writes, 'here duration is encountered as a trace of subtle movements, one instance to another, with the in-between

Jan Dibbets
12 Hour Tide Objects with
Correction of perspective
1969

Bas Jan Ader
I'm Too Sad to Tell You
1970
Photograph
45 × 59 cm

Michael Snow
Wavelength
1966–67
Film, 45 min., colour, sound

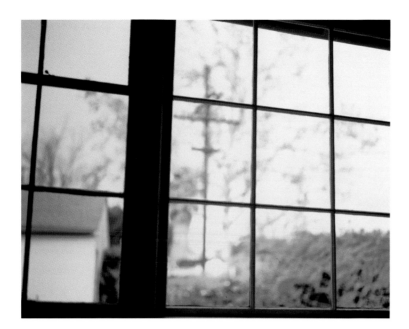 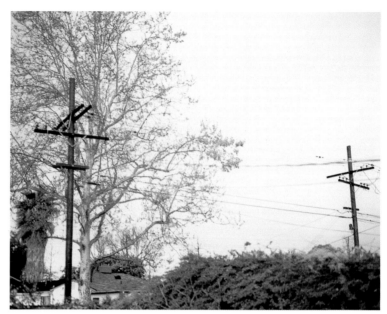

constituting a temporal unknown'.[39]

 With respect to this 'temporal unknown', *nowhere near* and *...and of time* function as two sides to the same perceptual coin. Taken together, the two suites of photographs mediate the border war between inside and outside, a seemingly impermeable arrangement that the logic of duration effectively defeats. With her most recent body of work, *white blind (bright red)* these kinds of reversals between intrinsic and extrinsic find a distinct correspondence in the exchange between subject and object, perceiver and perceived. Where, they seem to ask, does vision begin and end relative to the object; and at what point does the perceived stability of the object mesh with the phantasms of the imagination?

white blind (bright red)

The series that began this survey of Barth's work will at the same time, conclude it. And this is to the point for *white blind (bright red)* returns to and encompasses the range of Barth's concerns, organized, we could say, as both a formal and conceptual loop. Indeed *white blind (bright red)* plays upon the circularity of vision: how a

concerted or steady act of observation, extended across time and space, repeatedly returns to its point of departure in order to check itself or take measure of the accuracy of the visual data perceived. As suggested by my opening description of this work, it does this by means of its repetition of imagery within a specific sequence of photographs, which is in turn magnified with the 360 degree vista of its installation. As one moves from one picture to the next, the eyes begin to play tricks – or do they? The beholder repeatedly tests the appearance of optical phantoms against pictures viewed in and out of sequence.

 The view of bare trees against white sky in *white blind (bright red)* repeats the genre of imagery used in *nowhere near*. The individual perspectives, however, are neither taken from the same vantage point in the home nor offer the kind of spatial information of the earlier series. Indeed, if *nowhere near* was scrupulous in accounting for the most minuscule changes in light and the environment, the pictures that comprise *white blind (bright red)* appear largely schematic. The palette of each image tends to flatten the depths of the photograph: branches are nearly abstracted,

left, **nowhere near (nw 7)**
1999
Colour photographs
3 parts, 134.5 × 388.5 cm overall

below, **nowhere near (nw 4)**
1999
Colour photographs
2 parts, 89 × 228.5 cm overall
Collection Weatherspoon Art
Gallery, University of North
Carolina, Greensboro

nowhere near (nw 14)
1999
Colour photographs
2 parts, 89 × 228.5 cm overall

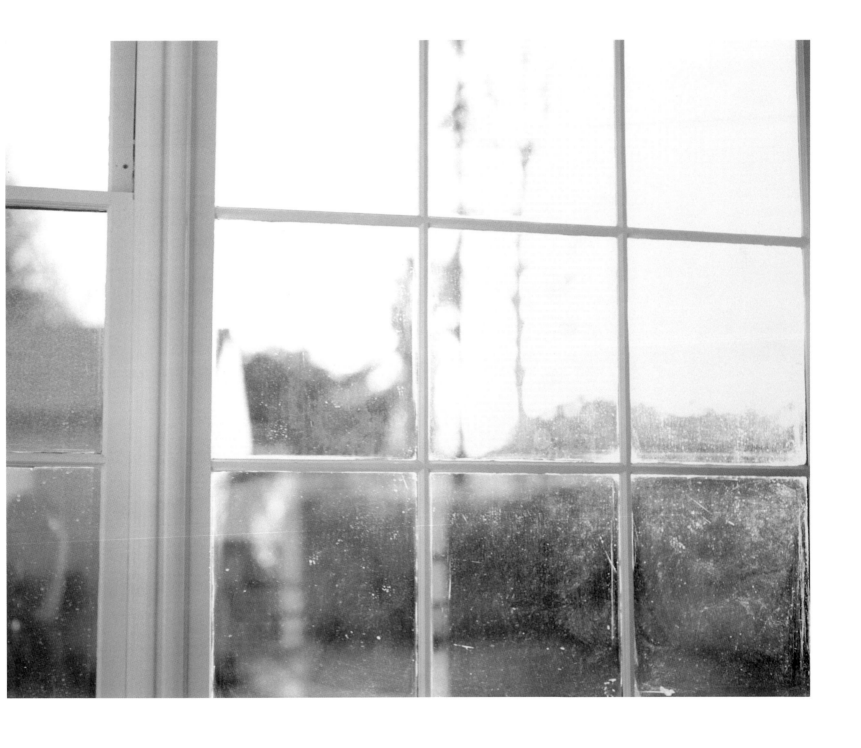

nowhere near (nw 19)
1999
Colour photographs
3 parts, 89 × 447 cm overall

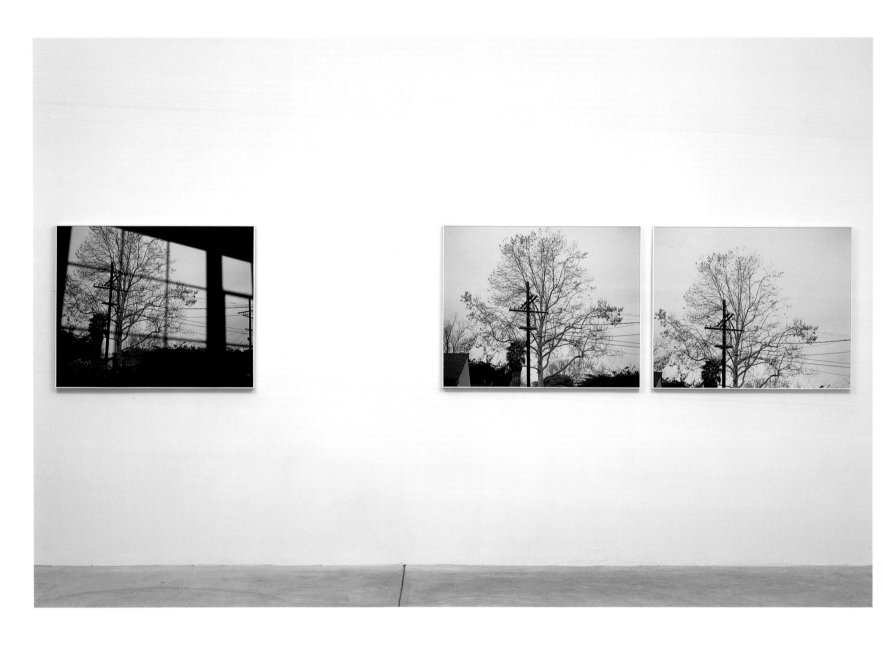

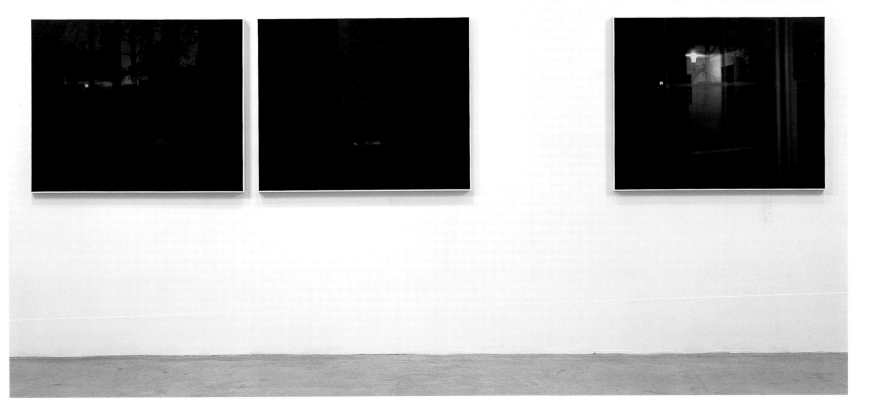

nowhere near (nw 15)
1999
Colour photographs
3 parts, 89 × 432 cm overall
Collection Lannan Foundation,
Santa Fe

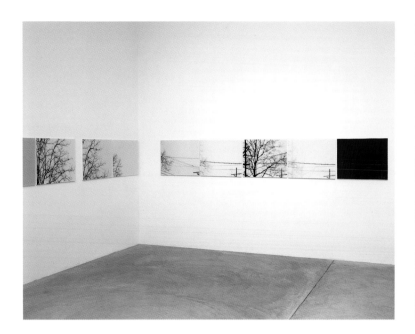 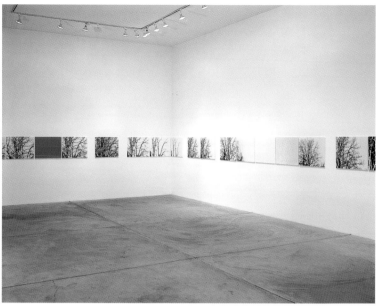

telephone poles are reduced to plain geometry, and telephone wires are drawn with the thinnest, least descriptive lines. We are, in other words, not so much given the details about the scene represented as we are offered a blunt gestalt of the elements occupying our visual field – an overarching form that impresses or even burns itself upon the ocular sense. This sensibility is achieved in part through a new technique the artist brought to the making of the series. *white blind (bright red)* is the first body of Barth's work in which the intervention of digital technology is pronounced; and her capacity to alter those images pixel by pixel is belied by the seemingly undifferentiated field of the pictures presented.

Yet through the endlessly variable points of view made possible by computer technology, Barth coaxes enormous difference from the scene of repetition. Her particular colour choices, likewise, offset a monolithic perspective of the imagery: a red panel, for one, will frame the viewing of an image that follows differently from a yellow one, and branches grounded by black will vibrate differently in the eye from those surrounded by white. This visual structure is not unlike the auratic

economy of a musical canon, or even minimalist music, in which two phases of a musical piece are played against each other. Like the experience of listening that attends these forms of music, where one is hard pressed to distinguish beginning from end, *white blind (bright red)* plays without relative failure to hold the visual gestalt of each image in isolation or suspense; to separate what we just saw from what we presently see.

white blind (bright red) inspires this reading partly because the photographs refuse to let our eyes focus. The distended forms of the trees connect like synapses to produce an ever-dynamic pattern of imagery, their branching structures are without symmetry. Lines are jittery, agitated. But the series also has recourse to the appearance of optical illusions – particularly the after-image – to implicate the experience of perception as endlessly variable and ever in motion.

To be sure, the logic of the after-image is foundational to both the mechanics and the imaginary of *white blind (bright red)*; and Barth's work is explicit in its acute regard for its power. An after-image is the ghostly impression of an image that appears to linger in one's visual field after the

eye is subjected to a repeated or uninterrupted stimulus. We can identify three examples of its operations. When looking at an object for a prolonged period, for one, its shadow figure seems to hover at the periphery of vision, even as we turn away. Similarly, if exposed to a bright or violent source of light – a camera flashing or a bolt of lightning – the eye receiving that information will briefly retain its form as a visual trace. The after-image might also be sparked off by particular colours. If you stare at a field of white long enough, blink and you might see that same field in red. By the same token, Barth reports that if the eye is immobilized – if its oscillation is frozen by disease or medical intervention – vision goes white: white blind.

When these variables are combined and extended over the visual plane, as they are in *white blind (bright red)*, the effect is such that we cannot separate what is *intrinsic* to each picture from our perceptual experience *extrinsic* to it. Where the image ends and where perception begins is the rhetorical question that these pictures seem to beg; it is rhetorical insofar as knowledge of the image is indivisible from the experience of viewing that produces it. As Barth herself remarks, scientists 'say that it is impossible to locate the point of distinction where the cells of the optic nerve turn into the brain.' Indeed, with Barth's sequencing of repetitive imagery, sometimes we imagine that the ghostly image of branches travel from a photographic image to a flatly coloured field. One work in the series consists of four panels, three of which feature the same general perspective on trees, their trunks parallel to the left framing edge. As our eyes scan the images from left to right and back again, we move from a photograph of branches shot against a white ground to a similar, though not identical, perspective whose values are reversed, the field now coloured black. This stark shift from white to black is offset by the colour of the branches in the second panel, which are not white, but employ a range of yellows that varies slightly within the picture. The third panel in the series, however, is a yellow panel that seems to flip the colour schema of the second picture, so that the entire ground (there is no figure) is saturated by the predominant yellow in the photograph adjacent to it. And it is the adjacency between all of these images that makes one pause to look more closely at this monochromatic field: is there an image of trees contained within it, or is that simply an after-image impressed upon my eye? This is followed by a fourth picture, in which the image's tonal values are reversed to their original format. Here, Barth has produced a viewing experience that riffs on the recursive temporality of a feedback loop. We constantly check between the individual panels to make sure what we think we see is actually there; and that act of checking will in its turn shape our perception of the image that follows.

The exercise is self-defeating, though. The longer we stare at the pictures – the more we attempt to parse their visual logic – the more we compound the effects of the after-image. Sometimes the colour panels actually do contain such visual information; at other times they do not. More than a few times we might narrow our gaze in a useless attempt to stop the proliferation

white blind (bright red)
2002
Mounted photographs
14 parts, each panel, 54 × 66.5 cm
Installation, ACME, Los Angeles

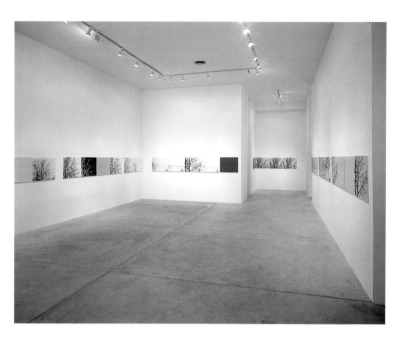 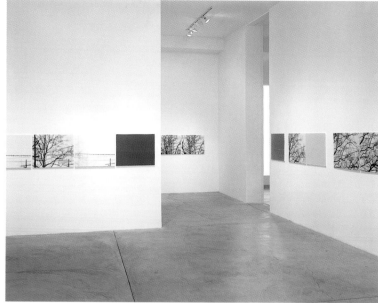

white blind (bright red)
2002
Mounted photographs
14 parts, each panel, 54 × 66.5
cm
Installation, ACME, Los Angeles

of the afterimage – the way in which it seems to bleed and echo into our discrete apperception of the visual field. *white blind (bright red)* seems to pace the moment at which vision begins to erode: it registers the point of what Barth calls 'optical fatigue'. What the Minimalists referred to as 'the crumbling of the visual gestalt' is instantiated through the systematic repetition of that form throughout the series, an act that might seem to secure our perception of the phenomenal world. The paradox, of course, is that the multiplication of similar images serves to dethrone vision. The composition is not so much shored up as progressively *decomposed*.

With *white blind (bright red)* Barth extends and returns to the questions posited in previous series. It recalls the multi-panelled work made in the early 1990s, which featured optical diagrams and pictures thematizing the violent economy of spectatorship; like the series ... *and of time* it admits to duration in the experience of viewing. It embraces the cinematographic in producing a horizon of temporally distended imagery; it evokes the act of staring, as in *nowhere near*. Where it departs from earlier series is in its explicit use of

digital technology. But no matter: whatever its difference in technique it nonetheless elaborates on the strictures placed on the visual sense and the conditions inflecting all matter of perception. Indeed, the seamless merging of digital and analogue vision in *white blind (bright red)* alerts us to the one element constant grounding Barth's production: if we take the question of perception seriously in her work, we must recognize that perception is no mere thing. It can neither be ontologized nor isolated to discrete activities or sense organs; nor can vision be made the fetish of the photographic medium. Barth, rather, shows us that perception is organized like an apparatus, with vision but one point in the constellation of the senses. And that very linking of the senses betrays what is ultimately partial about the human sensorium, with its limited possibilities for insight and the endless potential to fail.[40]

1 Maurice Merleau-Ponty, *Phenomenology of Perception*, translated by Colin Smith, Routledge, London, 1989, p. 329.

2 Uta Barth in Conversation with Marilu Knode, *Artlies Contemporary Art Magazine*, No. 7, June–July 1995, pp. 30–32.

3 Holly Meyers, 'Loaded Questions Amid the Treetops', *Los Angeles Times*, 25 October 2002.

4 Uta Barth in Conversation with Matthew Higgs, in this volume.

5 Ibid.

6 The 'Pictures' generation, which would also include artists Robert Longo, Jack Goldstein, Richard Prince and Troy Brauntach, was associated with the exhibition 'Pictures' held at Artists Space, New York, in 1978. Organized by Douglas Crimp and Helene Winer, the show has accrued canonical status in histories of Postmodernism: it explored the relationship between contemporary art and its strategies of appropriating the imagery of popular or vernacular culture. It bears saying, though, that Barth has worked more explicitly with found imagery derived from popular cultural sources, such as magazines, as in her set of ten lithographs entitled ... *in passing* (1997).

7 Uta Barth in conversation with the author, 23 January 2004.

8 The question of far seeing and near seeing – and related issues of visual attention – finds its foundational art-historical treatment in the work of Adolf Hildebrandt, followed by Alois Riegl. Jonathan Crary has done the most to historicize phenomena of visual attention relative to the art of the nineteenth century and burgeoning technologies of vision. See Jonathan Crary, *Suspensions of Perception*, The MIT Press, Cambridge, Massachusetts, 2002. Note too that Jan Tumlir has discussed Crary with regards to Barth's work.

9 'Ground and Field, Before and After: Uta Barth in conversation with Sheryl Conkelton', *In Between Places* (Sheryl Conkelton with essays by Russell Ferguson and Timothy Martin), Henry Art Gallery, University of Washington, Seattle, 2000, pp. 14–15.

10 Ibid., p. 65.

11 Uta Barth in conversation with author, 24 January 2004.

12 Conkelton, op. cit., p. 20.

13 Knode, op. cit., p. 31.

14 Barth in conversation with the author, 24 January 2004.

15 Conkelton, op. cit., p. 18.

16 See, for example, Andrew Perchuk, 'Uta Barth: Bonakdar Jancou Gallery', *Artforum*, New York, September 1998, p. 152.

17 The trope of the blur has served other readings of the *Grounds* beyond the work's alleged resemblance to Pictorialism. For some critics, the blur is the *punctum* of Barth's practice, following Roland Barthes' formative essay on photography, *Camera Lucida* (trans. Richard Howard, Flamingo, London, 1984). Barthes' elegiac meditation on the photograph, its capacity to attest to 'the that-has-been' suggests that the invention of photography instantiates a new understanding of our relationship to temporality. The photograph, he argues, 'divides the history of the world' and 'allow(s) me to compute life, death, the inexorable extinction of the generations'. In making this claim, Barthes distinguishes between two modes of signification in the photograph: the *studium* and the *punctum*. The studium refers to photographic meaning at the level of denotation, the meaning of a picture transparent and accessible to all who approach it. The punctum, etymologically grounded in the Latin word for 'trauma', stands in contrast to the studium's legibility. It is that which 'escapes language' in the photograph: it is a feature that is 'private' in its meaning and irreducible to code or representation.
In referring to the blurriness of her photography as a kind of punctum, Barth's commentators implicitly outline two interwoven conditions of the photographic medium. They seem to acknowledge, on the one hand, the camera's incapacity to produce a seamless visual field – its failure to transform the world into a transparent object of representation. On the other hand, the perception of the individual approaching that field (or taking the picture, for that matter) is treated as a function of relative privacy.

Our perception of the image is in excess of whatever form it may literally represent: that is, what the photograph announces, publicly, as its content, subject matter or narrative. The virtue of reading Barth's work through Barthesian terms, then, is that perception is taken as partial, bound up in the contingencies of the encounter between subject and object. See, for example, Amelia Jones, 'Uta Barth at domestic setting', *Art Issues*, November–December 1994, p. 41; Roy Exley, 'Uta Barth: New Works, London Projects', *Zing Magazine*, London, 1998, p. 193.

18 David A Greene, 'Warm and Fuzzy: For Photographer Uta Barth, All the World's a Blur', *Los Angeles Reader*, 3 November 1995, pp. 14–18.

19 On the question of contemporary art, the problem of medium and painting in particular, see the collected essays in *As Painting* (exhibition cat. The Wexner Art Center), ed. Philip Armstrong, Laura Lisbon and Stephen Melville, MIT Press, Cambridge, Massachusetts, 2001.

20 Carol Diehl, 'Uta Barth at Bonakdar Jancou', *Art in America*, New York, October 1998, p. 135.

21 Marilu Knode, op. cit., p. 37.

22 We would want to stay clear, of course, of the technologically deterministic argument that holds that the invention of photography quickly loosened painting's claims to representational accuracy. This notion suggests that photography effectively overtook painting's claims to representational mimesis, thus paving the way, through an invention in the media, for the abstraction that followed.

23 Turning to a more recent painterly comparison – namely, the work of Gerhard Richter – yields insight into how photography has literally mediated painting in its distribution, reception and circulation. The purposeful blurring of Richter's forms provides the most obvious point of entry into this parallelism, but his painting's touchstone in photography also extends the comparison. One would not want to press the comparison too much, though. The resemblance may ultimately prove superficial; and Barth herself has spoken of the diverging interests of their respective projects.

24 Knode, op. cit., p. 32.

25 Philip Steadman, *Vermeer's Camera: Uncovering the Truth Behind the Masterpieces*, Oxford University Press, 2001.

26 Conkelton, op. cit., p. 15.

27 Knode, op. cit., p. 32.

28 Elizabeth Smith, 'At the Edge of the Decipherable', *Uta Barth*, Museum of Contemporary Art, Los Angeles, 1995, p. 4.

29 Ibid.

30 See, for example, Robert Morris's three-part series of essays, 'Notes on Sculpture', in *Robert Morris: Continuous Project Altered Daily*, MIT Press, Cambridge, Massachusetts, 1993, pp. 1–26.

31 Knode, op. cit., p. 33.

32 In 1995 Barth was asked to show some of the *Grounds* at the Museum of Contemporary Art in Los Angeles in an exhibition organized by Smith. Although she originally envisioned it as a site-specific show, in which she would produce images of the museum's gallery, Barth did not make work directly in response to the museum, but her sensitivity towards the 'edge condition' of the image extended to the institutional ground against which the work was set in relief.

33 The principal formulation of apparatus theory in film is Jean-Louis Baudry, 'Ideological Effects of the Basic Cinematographic Apparatus', reprinted in *Narrative, Apparatus, Ideology: A Film Theory Reader*, edited by Phillip Rosen, Columbia University Press, New York, 1986, pp. 306–07. In addition to Baudry, the canonical essays include Christian Metz, 'The Imaginary Signifier', *Screen*, Vol. 16, No. 2, Summer, 1975, pp. 14–16. Jean-Louis Comoli, 'Techniques and Ideology: Camera, Perspective, Depth of Field', in *Movies and Methods Vol. II*, edited by Bill Nichols, University of California Press, Berkeley, 1985, pp. 40–57; and the feminist critique of apparatus theory in Jacqueline Rose, 'The Cinematic Apparatus – Problems in Current Theory', in *Sexuality in the Field of Vision*, Verso, London, 1986, pp. 199–215. Also see Stephen Heath and Teresa de Lauretis, eds., *The Cinematic Apparatus*, Macmillan,

London, 1980.

34 Jean-Louis Baudry, 'Ideological Effects of the Basic
 Cinematographic Apparatus', pp. 306–07.

35 Gilles Deleuze formulated the phrase 'any-instant-whatever' in
 relation to Henri Bergson's theories of duration; he applied it to the
 temporality of classical cinema. See Gilles Deleuze in *Cinema 1: The
 Movement-Image*, University of Minnesota Press, Minneapolis, 1996,
 translated by Hugh Tomlinson and Barbara Habherjin.

36 See Russell Ferguson, 'Into Thin Air', in Sheryl Conkelton, *In
 Between Places*, ibid., pp. 106–12.

37 Charles Labelle, 'Uta Barth: ACME Gallery, Los Angeles', *Art and Text*,
 No. 68, February–April 2000, p. 80.

38 On the subject of time and conceptual photography, see my 'The
 Austerlitz Effect: Time, Architecture, Photoconceptualism', in *The
 Last Picture Show*, cat., Walker Art Center, Minneapolis, 2002; and
 Alex Alberro, 'Time and Conceptual Art', in *Tempus Fugit: Time Flies*,
 ed. Jan Schall, Nelson Atkins Art Museum, Kansas City, 2001, pp
 144–57. Margaret Sundell draws the comparison between Barth and
 photoconceptualism, Margaret Sundell, 'Uta Barth: Bonakdar
 Jancou Gallery', *Artforum*, New York, January 2000, p. 115.

39 Timothy Martin, 'House and Extension', in *Uta Barth: …and of time*,
 Uta Barth in conjunction with the Getty Museum, Los Angeles,
 2000, p. 35.

40 Jan Tumlir is one of the few critics to address the notion of visual
 failure in Barth's work. See Tumlir, 'Uta Barth: ACME, Los Angeles',
 in *Art and Text*, No. 62, 1998, p. 90–91.

Field #9
1995
Colour photograph on panel
58.5 × 73 cm
Collection Museum of
Contemporary Art, Los Angeles

Untitled (98.11)
1998
Colour photographs
2 parts, 61.5 × 161.5 cm overall

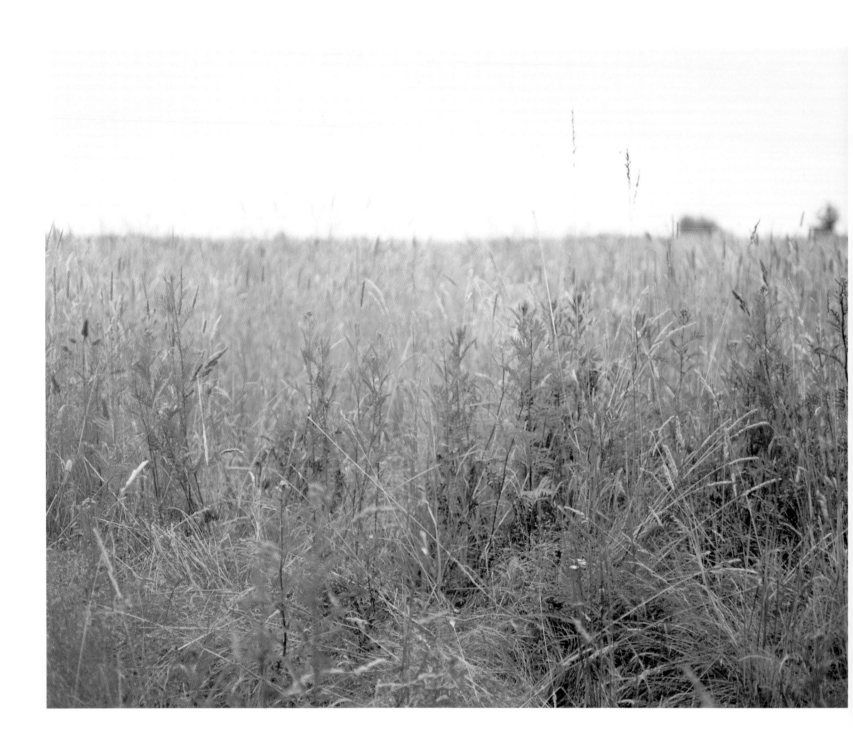

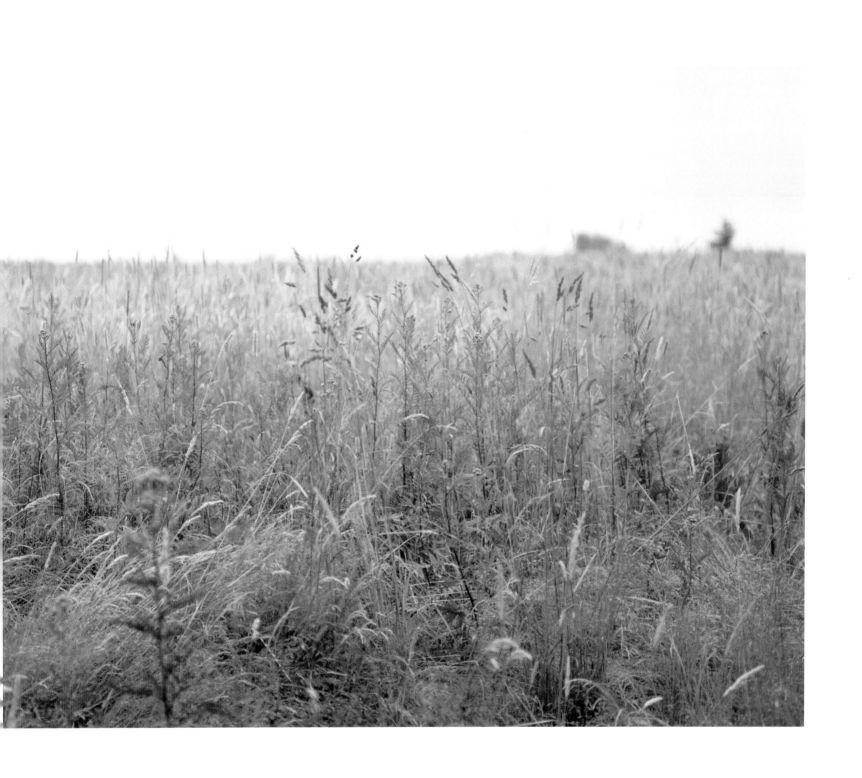

Contents

Interview Matthew Higgs in conversation with Uta Barth, page 6. Survey Pamela M. Lee

Uta Barth and the Medium of Perception, page 34.

Artist's Choice Joan Didion Democracy (extracts), 1994, page 110. Artist's

Writings Uta Barth Interview with Sheryl Conkelton, 1996, page 122. The Colour of Light in the Dark, 2004,

page 136. Chronology page 144 & Bibliography, List of Illustrations, page 158.

Focus Jeremy Gilbert-Rolfe Untitled (98.5), page 100.

Uta Barth's *Untitled (98.5)* (1998) is a landscape in three acts. In this sense it is a particularly good example of her approach: landscapes facilitate what she calls 'unmotivated looking'.[1] Barth wants her photography to be about looking *at* without looking *for* – as she puts it, 'looking that's not motivated by subject matter'. When preparing to take a photograph she waits until she is able to distance herself from her subject to the extent that she is 'staring into space', creating a sense of 'optical fatigue'. However, she believes that the camera is 'not good at replicating vision'. Specifically, it is unsuited to the indeterminate sense of temporal duration associated with the unmotivated gaze. Its lens may work in technical ways like the eye, but its fixed viewpoint does not resemble the mind. When taking in a space or surface over time without necessarily having a motive for doing so, one's attention does not remain transfixed, like a camera taking a long exposure. It wanders, hovering before and above things as often as it rests upon them; looking is as much an experience of time as of space. As with many of Barth's works, *Untitled (98.5)* attempts to replicate this indefinite, roaming focus. The work is untitled because it is about looking, rather than what is looked at. And Barth is more interested in making the photographic address the question of how the eye takes in a space over time than she is in photography's historical identity and teleology.

Untitled (98.5) was filmed over roughly forty-five minutes, using about fifty exposures. The resulting rainy, chilly-looking landscape, viewed from inside a room, can be compared with images from Michelangelo Antonioni's 1964 film *The Red Desert*. And one can describe this work cinematically: it records three moments of looking, a staggered temporal duration represented on three separate panels. The left-hand panel, in which the surface of the window closest to the camera is (almost) in focus, works as an establishing shot for the other two parts. In these the focus is on the space either just inside the window or just outside it – Barth cannot remember which and it is impossible to deduce.

While the first two panels are directly adjacent to each other, the second and third are separated by a gap. This is roughly the same width as another panel plus the surrounding strips of wall, but is in fact imperceptibly smaller. The gap device achieves two things simultaneously. By drawing one's attention to the wall, it refers to the space the work shares with the viewer when considered as an object. At the same time it presents temporal duration as at once spatial and irregular. The minute contraction of the space could suggest

above, **Michelangelo Antonioni**
The Red Desert
1964
Film, 120 mins., colour, sound

opposite, **Untitled (98.5)**
1998
Colour photographs
3 parts, 96.5 × 501.5 cm overall
Installation, 'Uta Barth: In
Between Places', Henry Art
Gallery, University of Washington,
Seattle, 2000
Collections Henry Art Gallery,
University of Washington, Seattle;
Whitney Museum of American Art,
New York

time lost as opposed to lapsed, indeterminate rather than readily calculable. The gap also creates a moment in which one leaves the world of the image in order to re-enter it at the final panel. In the course of the sequence of viewing, first one sees the rain-smeared surface of the windowpane; then, moving to the second panel, this dissolves in favour of a continuity between the very near and what is on the other side of the glass; subsequently, but not immediately afterwards, one experiences the further dissolution of all separations in favour of a continuity between near and far.

Throughout its history, photography has to a large extent been concerned with achieving clarity of a sort unavailable to the human eye; the central photographic tradition has also been motivated by a remorseless concentration on the object. To this end photographic technology developed a large camera with a small aperture that could produce an image in which nearly everything would be sharply defined, from the near foreground to infinity. Photographs became generically glossy for the same reason that nineteenth-century academic paintings were shiny. Varnish added sharpness to detail, brilliance to the

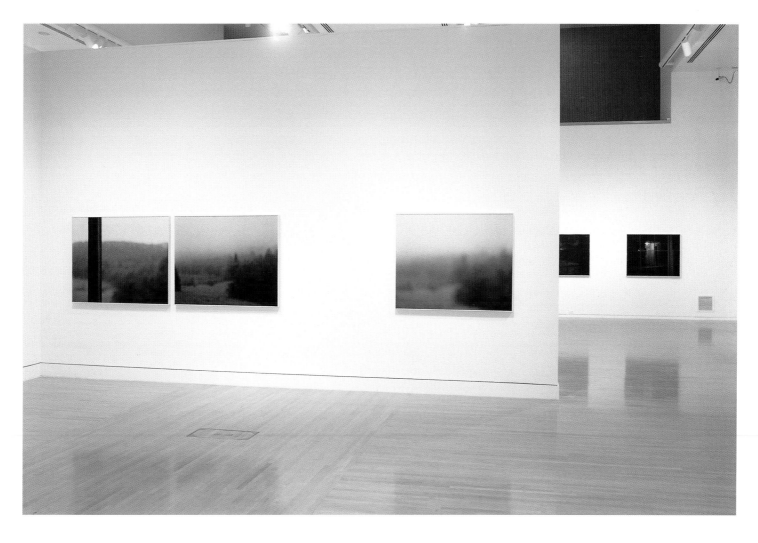

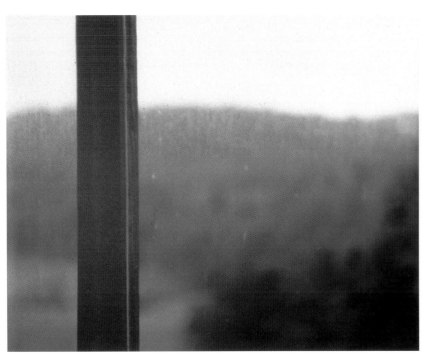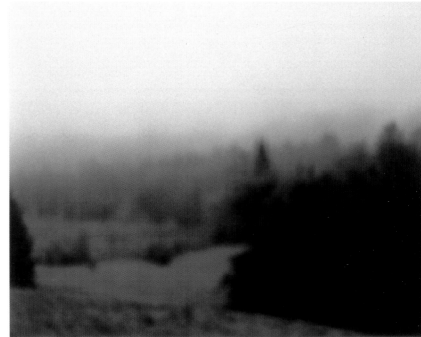

Untitled (98.5)
1998
Colour photographs
3 parts, 96.5 × 501.5 cm overall
Collections Henry Art Gallery,
University of Washington, Seattle;
Whitney Museum of American Art,
New York

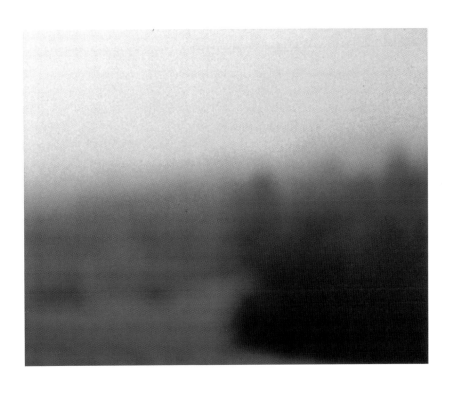

colour, and evened out the surface. The Impressionists and their successors gave this up, being indifferent to detail or evenness and having found a way to make colour much more brilliant than it had ever been before. One kind of immediacy was thus substituted for another. The shiny surface had helped one to become immersed in the illusion and to forget, if only for a moment, that one was looking at an object; the Impressionists did not want one to forget it. In the early stages of photography's development, the ambition for depth of definition was most fully realized by Timothy O'Sullivan and Anselm Adams, while the foremost contemporary representative of the technique is perhaps Andreas Gursky. In his more recent work photography's traditional impulse towards exceeding human vision in the interests of the hyper-realisation of objects is taken to a new level of intensity with the aid of digital adjustment.

Barth, on the other hand, never uses a tripod, chooses shots intuitively, and the print is never digitally or otherwise manipulated. The surfaces of her images are coated with a matt laminate, an unusual technique when she first started to use it but now popular with many photographers. Although it is more fragile than a glossy surface, Barth likes the way it looks, claiming, 'the more matt something is the more the surface disappears'. In *Untitled (98.5)*, the matt surface, in both joining and separating the depicted space of the image from the space of the viewer, echoes the window in the image, which acts in the same way in terms of the interior and exterior spaces on either side of it. Paradoxically, although the third panel, representing the furthest dissolution of the difference between near and far, constitutes the moment of the laminate's most complete disappearance, it is also where one is most emphatically aware of it. Similarly, while *Untitled (98.5)* is about being in a place, it emphasizes the *being* rather than the place, not the near and the far, but the far *in* the near (the exterior in the interior).

By setting up the camera so that it is not focused on anything, Barth allows photography to engage an aspect of one's experience of the visible that the camera was not designed to address, eschewing both clarity and objects. While the matt laminate is the opposite of photography's generically glossy surface, Barth otherwise describes herself as using a 'generic camera, generic film and lens'. Her choice of apparatus is a medium-format camera, limited in its technical abilities. The third image in *Untitled (98.5)* may dissolve forms and through that collapse distance, but just as the unmotivated is not simply the

Timothy O'Sullivan
Sand Dunes, Carson Desert
1867
Black and white photograph

Ansel Adams
Moon and Mount McKinley, Denali
National Park
1947
Gelatin silver print

Andreas Gursky
99 Cent
1999
Chromogenic colour print
207 × 337 cm

opposite of the motivated, *Untitled (98.5)* is not about the unfocused as the opposite of focus. It is about an alternative kind of photographic relationship to the idea of proximity and distance, which causes one to divide one's attention between an image of measureless depth and the matt surface.

Is this simply a work about being inside on a wet day? I would suggest that it might be, but in more than the obvious sense that these were the conditions of its manufacture. The indeterminacy of the work invites one to read it as an interior conditioned by its exterior. In the first photograph one seems to fall into the landscape as if coming close to look at the raindrops on the other side of the window pane: a detail leading to the unfocused. In the other two there is no detail; the camera focuses on nothing but space. The outside occupies the whole image and indeterminacy flourishes exponentially. Just as one cannot know where the focus is in the second and third photographs, it is not easy to guess where the photographer was positioned. In the third picture the spot that was occupied by the window bar in the first image is the place where the landscape is most watery and indistinct. Barth seems to have moved slightly back, to the right and up; a big change results from this tiny adjustment.

Instead of a landscape united by focus, high definition and detail, or one disunited by a disparity between what is clear and what is not – consistent clarity or gradated diminution from the clear to the unclear – *Untitled (98.5)* presents the near and far in terms that might be compared to what Heidegger calls 'remotion'. His claim is that it is because everything is '"remote" that there is something like nearness as a mode of distance'. He invents the word 're-moting [etymologically "removing distance"], *making distance disappear*', to describe how one experiences (or thinks) one's relationship to the world at large.[2] Having transformed the state of remoteness into a verb, Heidegger adds with pedantic defensiveness, 'Here we do violence to natural linguistic usage, but it is demanded by the phenomenon itself.'[3] This seems comparable to the phenomenon preoccupying Barth, in that she wants photography to engage what is also 'a mode of being, of pure *letting-become-present … that … is nothing other than time itself*'.[4] *Untitled (98.5)*, then, is about making distance present. The longer one looks at this work, the more one notes the differences between the colour of the sky in each one: light bluish grey in the first, deeper, more reddish grey in the second, greenish-grey in the third. The loss of definition from the first to the

third part is not entirely a product of where the camera is focused. Importantly, the changes in the weather had as much to do with the differences between shots as did the camera's focus. The image is the result of two variables: unpredictable shifts in point of view and equally unpredictable atmospheric change. *Untitled (98.5)* is about being inside on a rainy day in the sense that the light outside the room characterizes the room itself, and that time is a function of the changing landscape, which in its turn changes the interior from which it is viewed. Again, Heidegger comes to mind, irritably pointing out that the colour and shape of things and how we use them are not ancillary characteristics, but essential to what things are. The weather is outside, but the atmosphere it creates is inside the room. In this work Barth has photographed time itself, and the changing colours are as much a part of the inside as the outside, remoteness disappearing the longer one looks.

Tim Martin has written of Barth's '"choice of no choice", a decision to set the identification of the photographic locale aside, to take it for granted'.[5] In this sense it is helpful to compare Barth's move away from the specific, and her use of the matt laminate, with Gerhard Richter's articulation of the relationships between painting and photography.[6] Richter's paintings seem to suggest how nowadays we can only see a landscape (or anything else) as a photographic image. Like Gursky, he is interested in the properties of that image, while Barth, to extend Martin's term, insists on taking them for granted. If for Richter the generic properties of the medium are significant, for her the apparatus is only a means to an end, and moreover one that requires those properties to be inverted or frustrated. The matt laminate detaches photography from its generic identification with detail through a directly comparable gesture. It slows the viewer down, as does drawing attention to the photograph as a an object rather than an image. Until she started using larger images, as in *Untitled (98.5)*, when it became impossible for technical reasons, Barth mounted her photographs on panels, making them bulky like paintings, rather than putting them into frames. If Richter wants painting to appropriate photography's influence on vision and recognition, specifically by invoking the immediacy and intensification that one associates with photography's homogenous and impeccable laminated surface in its generically glossy state, Barth wants to introduce into photography painting's 'objectness' and with it (in an actively contradictory relationship) the staggered and discontinuous time that has become accepted in painting since Paul Cézanne. Cézanne attempted to stare at the same object or

Untitled (98.5)
1998
Colour photographs
3 parts, 96.5 × 501.5 cm overall
Collections Henry Art Gallery,
University of Washington, Seattle;
Whitney Museum of American Art,
New York

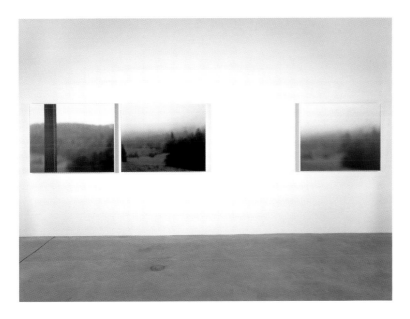

scene for long periods, like a camera taking a long exposure, but it was impossible to do this without his eye being torn from side to side. Barth's attention is not torn in this sense, but willingly attracted to many places or spaces in a visual field whose perimeter shifts from shot to shot. In this sense it will be interesting to see her new works, in which she is attempting to address time through a single print as opposed to a sequence of images.

One could say that in her interest in subjectivity as opposed to apparatus, in time and space but not history or technology, Barth is modern rather than postmodern – but if so, hers would be a peculiarly postmodern modernism. Postmodernism is a condition in which subjectivity itself is aware of its foundation in the apparatus as much as in nature, the former as well as the latter being therefore experienced as generic. It can take the apparatus for granted, as modernism – Cézanne for example – could not, and it can stare without anxiety as Antonioni would not wish to. Unlike Antonioni's work, Barth's is not about suspense; it has too often been described as depicting rooms where something is about to happen, or might recently have happened. Lost in a quest for a motive, such interpretations miss the opportunity to dwell on the particularities of being somewhere when that somewhere is nowhere in particular.

1 All quotes from Uta Barth are from her conversations with the author on 8 July and 4 August 2001.

2 Martin Heidegger, *History of the Concept of Time,* trans. Theodore Kisiel, Indiana University Press, Bloomington, Indiana, 1992, p. 227.

3 Ibid.

4 Ibid., pp. 213–24.

5 Tim Martin, 'A Little Background Noise (Excerpts)', in Sheryl Conkelton, *Uta Barth: In Between Places*, Henry Art Gallery, University of Washington, Seattle, 2000, p. 140.

6 See Jeremy Gilbert-Rolfe, *Beauty and the Contemporary Sublime*, Allworth Press, New York, 2000, p. 33.

Contents

Interview Matthew Higgs in conversation with Uta Barth, page 6. Survey Pamela M. Lee

Uta Barth and the Medium of Perception, page 34 Focus Jeremy Gilbert-Rolfe Untitled (98.5), page 100.

Artist's Choice Joan Didion Democracy (extracts), 1984, page 110. Artist's

Writings Uta Barth Interview with Sheryl Conkelton, 1996, page 122. The School of Looking, page 126.

page 136 Chronology page 144 & Bibliography, List of Illustrations, page 158.

Part 1, Chapter 1

The light at dawn during those Pacific tests was something to see.

Something to behold.

Something that could almost make you think you saw God, he said.

He said to her.

Jack Lovett said to Inez Victor.

Inez Victor who was born Inez Christian.

He said: the sky was this pink no painter could approximate, one of the detonation theorists used to try, a pretty fair Sunday painter, he never got it. Just never captured it, never came close. The sky was this pink and the air was wet from the night rain, soft and wet and smelling like flowers, smelling like those flowers you used to pin in your hair when you drove out to Schofield, gardenias, the air in the morning smelled like gardenias, never mind there were not too many flowers around those shot islands.

They were just atolls, most of them.

Sand spits, actually.

Two Quonsets and one of those landing strips they roll down, you know, the matting, just roll it down like a goddamn bathmat.

It was kind of a Swiss Family Robinson deal down there, really. None of the observers would fly down until the technical guys had the shot set up, that's all I was, an observer. Along for the ride. There for the show. You know me. Sometimes we'd get down there and the weather could go off and we'd wait days, just sit around cracking coconuts, there was one particular event at Johnston where it took three weeks to satisfy the weather people.

Wonder Woman Two, that shot was.

I remember I told you I was in Manila.

I remember I brought you some little souvenir from Manila, actually I bought it on Johnston off a reconnaissance pilot who'd flown in from Clark.

Three weeks sitting around goddamn Johnston Island waiting for the weather and then no yield to speak of.

Meanwhile we lived in the water.

Caught lobsters and boiled them on the beach.

Played gin and slapped mosquitoes.

Couldn't walk. No place to walk. Couldn't write anything down, the point of the pen would go right through the paper,

one thing you got to understand down there was why not much got written down on those islands.

What you could do was, you could talk. You got to hear everybody's personal life story down there, believe me, you're sitting on an island a mile and a half long and most of that is the landing strip.

Those technical guys, some of them had been down there three months.

Got pretty raunchy, believe me.

Then the weather people would give the go and bingo, no more stories. Everybody would climb on a transport around three a.m. and go out a few miles and watch for first light.

Watch for pink sky.

And then the shot, naturally.

Nevada, the Aleutians, those events were another situation altogether.

Nobody had very pleasurable feelings about Nevada, although some humorous things did happen there at Mercury, like the time a Livermore device fizzled and the Los Alamos photographers started snapping away at that Livermore tower—still standing, you understand, a two-meg gadget and the tower's still standing, which was the humorous part—and laughing like hell. The Aleutians were just dog duty, ass end of the universe, they give the world an enema they stick it in at Amchitka. Those shots up there did a job because by then they were using computers instead of analog for the diagnostics, but you would never recall an Aleutian event with any nostalgia whatsoever, nothing even humorous, you got a lot of congressmen up there with believe it or not their wives and daughters, big deal for the civilians but zero interest, zip, none.

He said to her.

Jack Lovett said to Inez Victor (who was born Inez Christian) in the spring of 1975.

But those events in the Pacific, Jack Lovett said.

Those shots around 1952, 1953.

Christ they were sweet.

You were still a little kid in high school when I was going down there, you were pinning flowers in your hair and driving out to Schofield, crazy little girl with island fever, I should have been put in jail. I'm surprised your Uncle Dwight didn't show up out there with a warrant. I'm surprised the whole goddamn Christian Company wasn't turned out for the lynching.

... in passing
1996
Boxed portfolio of waterless lithographs
31.5 × 28 cm each
Collections Seattle Art Museum;
Tate Gallery, London

...u need and
...vant?

Water under the bridge.

Long time ago.

You've been around the world a little bit since.

You did all right.

You filled your dance card, you saw the show.

Interesting times.

I told you when I saw you in Jakarta in 1969, you and I had a knack for interesting times.

Jesus Christ, Jakarta.

Ass end of the universe, southern tier.

But I'll tell you one thing about Jakarta in 1969, Jakarta in 1969 beat Bien Hoa in 1969.

'Listen, Inez, get it while you can,' Jack Lovett said to Inez Victor in the spring of 1975.

'Listen, Inez, use it or lose it.'

'Listen, Inez, *un regard d'adieu*, we used to say in Saigon, last look through the door.'

'Oh shit, Inez,' Jack Lovett said one night in the spring of 1975, one night outside Honolulu in the spring of 1975, one night in the spring of 1975 when C-130s and C-141s were already shuttling between Honolulu and Anderson and Clark and Saigon all night long, thirty-minute turnaround at Tan Son Nhut, touching down and loading and taxiing out on flight idle, bringing out the dependants, bringing out the dealers, bringing out the money, bringing out the pet dogs and the sponsored bar girls and the porcelain elephants: 'Oh shit, Inez,' Jack Lovett said to Inez Victor, 'Harry Victor's wife.'

Last look through more than one door.

This is a hard story to tell.

Part 1, Chapter 2

Call me the author.

Let the reader be introduced to Joan Didion, upon whose character and doings much will depend of whatever interest these pages may have, as she sits at her writing table in her own room in her own house in Welbeck Street.

So Trollope might begin this novel.

I have no unequivocal way of beginning it, although I do have certain things in mind. I have for example these lines from a poem by Wallace Stevens:

The palm at the end of the mind,

Beyond the last thought, rises

In the bronze distance,

A gold-feathered bird

Sings in the palm, without a human meaning,

Without human feeling, a foreign song.

Consider that.

I have: 'Colours, moisture, heat, enough blue in the air', Inez Victor's fullest explanation of why she stayed on in Kuala Lumpur. Consider that too. I have those pink dawns of which Jack Lovett spoke. I have the dream, recurrent, in which my entire field of vision fills with rainbow, in which I open a door on to a growth of tropical green (I believe this to be a banana grove, the big glossy fronds heavy with rain, but since no bananas are seen on the palms symbolists may relax) and watch the spectrum separate into pure colour. Consider any of these things long enough and you will see that they tend to deny the relevance not only of personality but of narrative, which makes them less than ideal images with which to begin a novel, but we go with what we have.

Cards on the table […]

Part 2, Chapter 3

Aerialists know that to look down is to fall.

Writers know it too.

Look down and the prolonged spell of suspended judgment in which a novel is written snaps, and recovery requires that we practise magic. We keep our attention fixed on the wire, plan long walks, solitary evenings, measured drinks at sundown and careful meals at careful hours. We avoid addressing the thing directly during the less propitious times of day. We straighten our offices, arrange and rearrange objects, talismans, props. Here are a few of the props I have rearranged this morning.

Object (1): An old copy of *Who's Who*, open to Harry Victor's entry.

Object (2): A framed cover from the April 21, 1975, issue of *Newsweek*, a black-and-white photograph showing the American ambassador to Cambodia, John Gunther Dean, leaving Phnom Penh with the flag under his arm. The cover reads 'Getting Out.' There are several men visible in the background of this photograph, one of whom I believe to be (the background is indistinct) Jack Lovett. This photograph would have been taken

… in passing
1996
Boxed portfolio of waterless
lithographs
31.5 × 28 cm each
Collections Seattle Art Museum;
Tate Gallery, London

during the period when Inez Victor was waiting for Jack Lovett in Hong Kong.

Objects (3) and (4): two faded Kodacolor snapshots, taken by me, both showing broken rainbows on the lawn of the house I was renting in Honolulu the year I began making notes about this situation.

Other totems: a crystal paperweight to throw colour on the wall, not unlike the broken rainbows on the lawn (dense, springy Bermuda grass, I remember it spiky under my bare feet) outside that rented house in Honolulu. A map of Oahu, with an X marking the general location of the same house, in the Kahala district, and red push-pins to indicate the locations of Dwight and Ruthie Christian's house on the Manoa Road and Janet and Dick Ziegler's house on Kahala Avenue. A postcard I bought the morning I flew up from Singapore to see Inez Victor in Kuala Lumpur, showing what was then the new Kuala Lumpur International Airport at Subang. In this view of the Kuala Lumpur International Airport there are no airplanes visible but there is, suspended from the observation deck of the terminal, a banner reading 'Welcome participants of the Third World Cup of Hockey.' The morning I bought this postcard was one of several mornings, not too many, four or five mornings over a period of some years, when I believed I held this novel in my hand.

Part 4, Chapter 4

[...] In March of 1976 Billy Dillon showed me the thirteen-word reply he got to a letter he had written Inez. He had resorted to writing the letter because calling Inez had been, he said, unsatisfactory.

'Raise anything substantive on the telephone', Billy Dillon said when he showed me Inez's reply, 'Mother Teresa out there says she's wanted in the clinic. So I write. I give her the news, a little gossip, a long thought or two, I slip in one question. One. I ask if she can give me one fucking reason she's in goddamn K L, and this is what I get. Thirteen words.'

He handed me the sheet of lined paper on which, in Inez's characteristic scrawl, the thirteen words appeared: *'Colours, moisture, heat, enough blue in the air. Four fucking reasons. Love, Inez'*.

Colours, moisture, heat.
Enough blue in the air.

... in passing (detail)
1996
Boxed portfolio of waterless
lithographs
31.5 × 28 cm each
Collections Seattle Art Museum;
Tate Gallery, London

I told you the essence of that early on but not the context, which has been, you will note, the way I tried to stay on the wire in this novel of fitful glimpses. It has not been the novel I set out to write, nor am I exactly the person who set out to write it. Nor have I experienced the rush of narrative inevitability that usually propels a novel toward its end, the momentum that sets in as events overtake their shadows and the cards all fall in on one another and the options decrease to zero.

Perhaps because nothing in this situation encourages the basic narrative assumption, which is that the past is prologue to the present, the options remain open here.

Anything could happen.

As you may or may not know Billy Dillon has a new candidate, a congressman out of NASA who believes that his age and training put him on the right side of what he calls 'the idea lag,' and occasionally when Billy Dillon is in California to raise money I have dinner with him. In some ways I have replaced Inez as the woman Billy Dillon imagines he wishes he had married. Again as you may or may not know Harry Victor is in Brussels, special envoy to the Common Market. Adlai and Jessie are both well. Adlai in San Francisco, where he clerks for a federal judge on the Ninth Circuit; Jessie in Mexico City, where she is, curiously enough, writing a novel and living with a *Newsweek* stringer who is trying to log in enough time in various troubled capitals to come back to New York and go on staff. When and if he does I suspect that Jessie will not come up with him, since her weakness is for troubled capitals. *Imagine my mother dancing*, I had hoped Jessie's novel would begin, but according to a recent letter I had from her this particular novel is an historical romance about Maximilian and Carlota.

Inez of course is still in Kuala Lumpur.

She writes once a week to Jessie, somewhat less often to Adlai, and scarcely at all now to Harry. She sends an occasional postcard to Billy Dillon, and the odd clipping to me. One evening a week she teaches a course in American literature at the University of Malaysia and has dinner afterwards at the Lake Club, but most of her evenings as well as her days are spend on administration of what are by now the dozen refugee camps around Kuala Lumpur.

A year ago when I was in London the *Guardian* ran a piece about Southeast Asian refugees, and Inez was quoted.

She said that although she still considered herself an American national (an odd locution, but there it was) she would be in Kuala Lumpur until the last refugee was dispatched.

Since Kuala Lumpur is not likely to dispatch its last refugee in Inez's or my lifetime I would guess that she means to stay on, but I have been surprised before. When I read this piece in London I had a sudden sense of Inez and of the office in the camp and of how it feels to fly into that part of the world, of the dense greens and translucent blues and the shallows where islands once were, but so far I have not been back.

... in passing
1996
Boxed portfolio of 10 waterless
lithographs
31.5 × 28 cm each
Collections Seattle Art Museum;
Tate Gallery, London

Joshua Tree

Park Blvd

Keys View

Jumbo Rock

Contents

Interview Matthew Higgs in conversation with Uta Barth, page 6. Survey Pamela M. Lee Uta Barth and the Medium of Perception, page 34. Focus Jeremy Gilbert-Rolfe Untitled (98.5), page 100. Artist's Choice Joan Didion Goodbye to y journalist, 1961, page 118. **Artist's Writings** **Uta Barth** Interview with Sheryl Conkelton, 1996, **page 122.** The Colour of Light in Helsinki, 2004, **page 136** Chronology page 144 & Bibliography, List of Illustrations, page 156.

Sheryl Conkelton In each of your series, beginning with your earliest work, you have explored the formal and cultural conventions of image making, drawing attention to problematic aspects encountered in the production of imagery and in the reading/ response to it. Your early work was confrontational in its conception and its presentation; I'm thinking about the early photographs of you under an interrogating gaze that were shown at the Los Angeles Institute of Contemporary Art (LAICA) as well as the mix of optical illusion, abstraction and photographed vignettes from the *Untitled* series shown in 'Deliberate Investigations' at the Los Angeles County Museum of Art in 1989. The *Ground* series is much more seductive (as are the *Fields*). Would you talk about your moving from a somewhat aggressive stance in the earlier series to this more unified and quieter imaging in the latest series, and about the effect on the viewer you are exploring?

Uta Barth **Actually the shift was not dramatic. One body of work literally grew out of the other. The very first 'background' images appeared within the groupings you mention, juxtaposed with optical painting, large monochromatic fields of colour and other photographs. I became very interested in them and started a separate series of landscape backgrounds which were based on vernacular conventions/snapshot photography of people in front of scenic landscapes. At that time I had made a very conscious decision to produce several projects that were formally quite different yet linked by addressing different aspects of vision, thereby bringing the activity of looking to the foreground as the common denominator. I wanted these three formally and structurally quite different projects to be exhibited simultaneously so it would be evident that the territory of the work was at the point of intersection. Previously people tended to get easily lost by the formal aspects of my work or became preoccupied by reading a certain 'politic of the gaze' as the overpowering and singular 'meaning,' and I wanted to confuse and complicate that reading and shift into larger questions that could cover more territory. At a certain point I felt that the background images, in and of themselves – in a much simpler way – did what I wanted my work to do for a long time: they quite literally inhabit the space between the viewer and the piece hanging on the wall and they do transfer one's visual attention beyond the edges of the picture, on to the wall it is hanging on, into the room as a whole, to the light in the room and even outside again … Their scale and composition is vaguely familiar, reminiscent of other pictures we may know. I am interested in the quietness of the new work and how that allows these associations to be noticed.**

Conkelton The spectator plays a very active role in arriving at/determining meaning for your work. Could you elaborate on that role in terms of what you intend as well as the larger (aesthetic or philosophical) significance of the viewer's participation?

Barth **It seems to me that the work invites confusion on several levels, and that 'meaning' is generated in the process of 'sorting things out.' On the most obvious level we all expect photographs to be pictures of something. We assume that the photographer observed a place, a person, an event in the world and wanted to record it, point at it. There is always something that motivated the taking of a photograph. The problem with my work is that these images are really not of anything in that sense, they register only that which is incidental and peripheral implied. Instead, there are some clues to indicate that what we are looking at is the surrounding information. (The images lack focus because the camera's attention is somewhere else. Many of the compositions, while clearly deliberate and carefully arranged in relation to the picture's edge, are awkward, off balance and formally suggest a missing element.) Slowly it becomes clear that what we are presented with is a sort of empty container and it is at that point that people begin to 'project' into this space. It begins to read as an empty screen. A second aspect might be that many people relate to the pictures in terms of memory. They are pretty saturated with the formal conventions of portraiture and one has a sense of inescapable familiarity when looking at them. What comes to mind is an entire inventory of other pictures seen. The point of engagement that perhaps interests me the most, though, has to do with one's perceptual reorientation in relation to the pictures when trying to decode the space described. If the 'subject' is not fixed within the image on the wall, but instead is indicated to be in front of that, then the 'location' of the work hangs somewhere between the viewer and the wall, in that empty space we are looking through. In some images, when you locate the camera's point of focus, you will find it to be that of an extreme close-up. The location of the implied subject is pushed so far forward that it aligns itself with the very place one is standing in front of the picture. So suddenly the imagined 'subject' and the viewer are standing in the same place. The dynamic brings to mind one of the traditional questions raised about Minimalist art: what has happened to the subject/where is the subject located when you are looking at an empty room or a seemingly blank wall? The answer, of course is that the viewer is the subject in/of this work.**

Conkelton I am interested in the notion of confusion, in its usefulness – even power – as a mechanism that triggers or motivates a viewer's response. I think it relates to Minimalism, too, in this way: that Minimal art proposes that a viewer relocates her or his self in relation to the object and its space, presenting a confrontation or a confusion of subject and object.

Barth **A certain kind of confusion or questioning is the starting place of confronting much of the work. Certain expectations are unfulfilled: expectations of what a photograph normally depicts, of how we are supposed to read the space in the image, of how a picture normally presents itself on the wall (contained and enclosed by a frame that demarcates the area of interest and separates it from all that surrounds it in the room), etc. This kind of questioning and reorientation is the point of entry and discovery, not only in a cognitive way, but in an most visceral, physical and personal sense. Everything is pointing to one's own activity of looking, to an awareness and sort of hyper-consciousness of visual perception. The only way I know how to invite this experience is by removing the other things (i.e., subject matter) for you to think about. I think all of this adds up to the conflation of subject and object that you are asking about.**

Conkelton I also think that the confusion/relocation of subject is key to the work in terms of actual and discursive spaces that the pieces work in. I am interested in the oscillation of 'subject,' or more precisely, in the relocation of the meaning between photography's referential, phenomenological aspect and its discursive, ontological aspect. In both the *Ground* and *Field* series there are multiple possibilities: to respond to the photographs as images of something, as objects in a room with particular visual and physical relationships, and as critical inquiry into the nature of photographic reproduction and its limits. I see this tension as a site of engagement and power in your images. There is also an effective tension in the relationship of your images to abstract painting in terms of a shared formal character. That is obviously intentional. Is there a particular aspect, whether it is a subversion of expectation or even a reference to past conceptualizations about these media – painting and photography – that is compelling to you?

Barth **I think the relationship to abstract painting exists most in the interiors. I am not sure how intentional this was at the outset of the project, but at a certain point I realized that my process of selecting, framing and composing these photographs which had no central subject shared much of the territory of, and produced pictures that look similar**

Gerhard Richter
Record Player (from the series
October 18, 1977)
1988
Oil on canvas
62 × 83 cm

to, certain Minimalist, abstract painting. It is an odd intersection of two projects that at a certain point share a similar investigation. I am interested in this intersection and what it may tell us about the relationship of the two. I obviously invite and acknowledge it, by even the titling of the work: 'ground' as in foreground/background, but also figure/ground or even the physical material/surface a painting is made on. I am interested in looking at the interplay between these photographs and particular issues of painting, but I am not using one medium to simply re-enact the qualities and characteristics of another. It is not my project to make photographs that 'look just like paintings'. I think the idea of producing photographs that would simply imitate, mimic or in other ways aspire (implying some odd hierarchy) to be 'just like paintings' would be rather problematic and pointless. I know that this is an aside to what you are asking about, but it might be a place to address a related question about all of the *Ground* and *Field* pieces which I hear frequently. What I am thinking about is the reading and description of the use of blur in my work as 'painterly.' I think this is quite inaccurate. Blur, or out-of-focusness due to shallow depth of field, is an inherent photographic condition; actually it is an inherent optical condition that functions in the human eye in exactly the same way it does in a camera lens. It is part of our everyday vision and perception, yet for the most part we are not very aware of it, as our eyes are constantly moving and shifting their point of scrutiny. We do not 'see' it unless we make a conscious effort to observe the phenomenon. The camera can 'lock-in' this condition and give us a picture which allows us to look at (and focus on) out-of-focusness.

Conkelton I'd like you to talk about the superficial resemblance of your work to some of Gerhard Richter's efforts: it seems to me (and to others) that Richter is interested in the spectacle of the photographic image of paint and in the reproduction of reproduction, and in the critique of modernism implicit in both these things, whereas your work has always been tied to an investigation of the physiological act of seeing – more immediate, about sensation and allusion; about locating oneself in relation to the work and then to a conceptualization that is not necessarily critique. Would you talk about these ideas?

Barth I get asked about Richter very often, and while I am a great admirer of his work I am not sure that I can see much, if any, relationship in what we are doing. The comparison is always based on the use of blur, on a similar look to the work. I do think we each end up with this for very different reasons. In my work much of the information

in the picture is out of focus because what is depicted in the image lies behind the camera's plane of focus. This has been a device for indicating a foreground, for implying the information not depicted and for lifting that plane off the wall toward the viewer. I think that originally Richter's use of blur came about through creating numerous generations of source material, working from photographs that had been printed in newspapers, then Xeroxed, often repeatedly. The information of the original image became more and more diffuse with each generation and he hung on to the look of that in the paintings, even exaggerating it more. The primary effect of this blurriness in both of our work is that the image becomes generalized, almost generic. Specificity of time and place drop away and one starts to think about the picture, as much as what it is of. I think Richter and I are both making pictures of and about other pictures. I have never been interested in making a photograph that describes what the world I live in looks like, but I am interested in what pictures (of the world) look like. I am interested in the conventions of picture making, in the desire to picture the world and in our relationship, our continual love for and fascination with pictures. I want my work to function on two levels: to elicit the sense of familiarity of looking at an image that has the structures and conventions of a history of picture-making embedded in it, to make you aware of that, and at the same time to shift your attention to the very act of looking (at something) to your own visual perception in that particular moment, in the particular place that you are viewing the picture in. These two things are related.

As far as your question about a 'critique of modernism,' I think that this critique is so deeply embedded (and embraced) in much of the work that I see being made these days, but it is seldom at the forefront. Maybe it is an argument that has been made, something that we know and work within at this point in time. In looking back it appears that some of the dividing lines between modernism and postmodernism are blurring and some of the areas of investigation that were thrown out are being revisited and rethought. Even thinking about Richter's work, it seems to me that his current painting, in its choice of subject matter, is moving through an archive of what I see as quintessential German imagery, German cultural iconography ... I read this as an analysis, an act of collecting and examining, of listing, but not necessarily as a critique.

Field #5
1995
Colour photograph on panel
58.5 × 73 cm
Collection Los Angeles Museum of
Contemporary Art

Conkelton An important aspect of your work, particularly in the images of interiors in the *Ground* series, is affected by site-specific installations that recreate the relationship of image and exhibition space. This concern in some way overrides the conceptualization of

opposite, **Ground #30**
1994
Colour photograph on panel
56 × 45.5 cm
Collection Lannan Foundation,
Santa Fe

below, **Jan Vermeer**
The Milkmaid
c. 1658–60
Oil on canvas
45.5 × 41 cm

the images as containers. Do these interiors, in fact, function very differently from the landscapes in the *Ground* and *Field* series?

Barth **Yes, I think you are absolutely right about that. The interiors, by sort of laying claim to all of the surrounding space, indite the whole environment, whatever room they are shown in, as part of the work. The project becomes architectural in some sense and, I think, to some degree the space itself becomes the piece and functions as the site of engagement. The *Fields* are very different in this way. They line up on the wall, in the same scale and screen-like format, spaced irregularly in a way to give the empty wall area as much importance as the actual pieces. They are clearly pictures of other places, outdoor scenes and at best double as a screen within the gallery environment. They are more optical, do not have a static composition of the *Grounds*, and imply movement both by the camera and whatever activity that is motivating the image. One has a sense of being made aware of one's peripheral vision, of what you see when you turn your head toward something, of what you might see while in motion.**

Conkelton How do you choose your subjects for the individual pictures. Do you have an actual (existing) film image or photograph in mind? Are you working from a typological model (for which you might have a list of types of images that you are trying to exhaust)? Or is it more intuitive and experiential?

Barth **The first images of the *Ground* series were chosen by seeking out the stereotypical, vernacular, visual vocabulary of what might constitute an ideal scenic or picturesque backdrop. They are almost a listing and re-enactment of the most commonly found choices. Most of the images in this series are of nature, some are based on the backdrop conventions of portrait-studio photography – but even there most of the references, while sometimes abstracted, are still of an idealized nature (as in the mottled blue seamless background paper used in yearbook and driver's licence pictures to mimic a sunny blue sky). The references to existing images in the interior works become much more subtle. At a certain point of that project I realized that one of the images I had made (*Ground #30*, 1994) had the exact same proportions, layout of the room and quality of light as that of a Vermeer painting (*The Milkmaid, c.* 1658–60) that I had spent much of my life looking at. This was unintentional on my part when I made this photograph, but it seemed that Vermeer was the perfect subtext for this**

body of work, and as a reference I made an additional image in the series (*Ground #42, 1994*) which included, in the background, the two small Vermeer reproductions I had grown up with in my home. I have obviously spent much time looking at various periods and styles of portrait painting and photography, ranging from the very self-consciously posed to casual family snapshot images. Early black-and-white Hollywood glamour photography is very interesting for example. Many of these images were made on white sets and the information in the background was created purely through the use of light and shadow. The shadows were often cast by objects and simple geometrical shapes arranged to create some kind of compositional balance in relation to the individual posed for the picture, and these objects are not visible in final photograph. Many of the recent interior images I have made consist almost exclusively of shadow information.

Some other pieces are loosely based on observed imagery that has been overused to impart meaning through context: the large bookcase behind the seated interviewee imparts intellectual authority, the woman posed by the spray of cherry blossoms assumes their beauty and fragility … once you become aware of these clichés you see them everywhere, in the pictures of authors found inside book jackets, on the evening television news and interview programs, etc. These are very clumsy ways to assign meaning. I find them amusing and interesting and have used them in several images of my own. The images in the *Field* series work much the same way. Most are based on some visual device I have observed in a film, but they are not literal recreations of a particular scene. I think I do have certain styles of filmmaking in mind when I go out to photograph. I end up driving around various neighbourhoods of the city looking for a place that is general, neutral enough to not interfere or visually compete with what might take place in the foreground … it is kind of like location scouting. It is not random: I am definitely looking for a place that has very particular, 'atmospheric' characteristics.

Conkelton Many of your installations of works from the recent series are predicated on an ensemble of images working within the confines of a particular space, and you are now in fact working on two projects in which you work very directly with a specific space. How do you proceed with a site-specific project in terms of creating or selecting the images that it comprises?

Field #8
1995
Colour photograph on panel
58.5 × 73 cm
Collection Solomon R.
Guggenheim Museum, New York

Barth **The 1994 exhibition at domestic setting [a Los Angeles gallery] was the beginning of the interior project and it was a site-specific piece. This gallery existed in an empty house, and many of the early interior images were photographs made in and for this space. Much of the show consisted of photographs that were pictures of the very wall they were hanging on and the series as a whole was designed for that space. I imagined the space as a home and made pieces that would double for the kind of pictures one might find there. Therefore all of the pieces from this series are different sizes and formats. They were hung in small clusters and pairings throughout the house, in corners and hallways, above the fireplace, much as a collection of family portraits and other pictures might exist in a home. When pieces from this project were installed in other exhibition sites like the Museum of Contemporary Art in Los Angeles, or the Rooseum in Sweden, they still retained some site-specific quality. Most empty corners and doorways do look alike, so when a picture of a corner is moved to a new space it still tends to read as relating to that particular location. Recently I was commissioned by the Wexner Center to make a work based on their exhibition space, which is a very visually assertive building by Peter Eisenmann. I looked at many floor-plans and photographs of the space before I flew out to see it, and when I spent some time inside the galleries I decided that what I wanted to do was not so much reiterate or even address the overt aspects of the architecture, but instead find a way to articulate the space the viewer would occupy in this very spectacular kind of building. I wanted to find a way to redirect the attention. The piece (*Ground #96.1, Ground #96.2, Ground #96.3*, 1996) is simple and consists of three very large photographs of two opposing walls in the north gallery. Two images depict the empty exhibition wall and part of the glass work rising above. The third image is of the opposing wall and it includes, at the very edge, a partial view of a pillar which is located in the centre of the gallery space. This pillar is the only information that is depicted in sharp focus in these photographs, thereby articulating the centre of the gallery space – the place where you might stand to view the art or the building – as the arena of investigation. The end result of the piece is that these three large photographs of empty walls are actually pointing at and describing the centre of the room.**

Conkelton What other projects are you working on now that expand the themes we've been talking about or move you in a new direction?

opposite, l. to r., **Ground #96.2**
1996
Colour photograph on panel
114.5 × 147.5 cm

Ground #96.1
1996
Colour photograph on panel
114.5 × 147.5 cm

right, **Ground #96.3**
1996
Colour photograph on panel
114.5 × 147.5 cm

Barth **Looking back, I find all of this work linked by an interest in visuality and perception. Light has been a theme throughout: in early instances it appears as invasive, interrogational and blinding. In more recent images it is atmospheric and all-engulfing. My primary project has always been in finding ways to make the viewer aware of their own activity of looking at something (or in some instances, someone.) The highly optical pieces did this in a rather jarring, confrontational way – inviting voyeurism and at the same time hindering or frustrating your ability to see and decipher an image, the current work by straining your perception of things that are barely visible, in some instances depicting pure light itself. For many years now I have been collecting pictures in which the background interests me, sometimes for purely formal and compositional reasons, at other times because the type of location or subject matter or even some odd relationship occurs between background and subject. Mostly I find them in newspapers and magazines and I cut and crop out the section of interest to me and pin it to my studio wall. I have never directly recreated or reproduced any of these found pictures, but have made images based on them. Recently I have become very interested in this collection of small clippings in and of themselves. They have served as source material, yet function in a very interesting way on their own. Most of them include a small section of a figure that has been cut away. They have a shoulder, a hand or part of a face at the very edge, but because of the way I have cut them, the centre of the pictures, the place we are trained to look at, is now empty. I am currently working with a small collection of these images which started out as notes and source material and using them in a recently published small sketchbook-like portfolio.**

Sheryl Conkelton, 'Uta Barth' (1996), *Journal of Contemporary Art*, Vol. 8, No. 1, Summer, 1997; Klaus Ottmann, editor; www.jca-online.com/barth.html. Reprinted in *Uta Barth: In Between Places*, Henry Art Gallery, University of Washington, Seattle, 2000.

The Colour of Light in Helsinki
2004

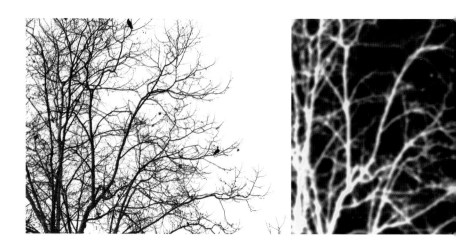

'What about perception?'

For years I have been talking about my work in terms of perception and countering other, more romantic, interpretations of it. Visual perception has been and continues to be the primary point of entry for thinking about the art I make, and for most of the things I do and I think about. Some time ago, while working on a text about my work, critic Timothy Martin asked me what I thought was a startling – and quite annoying – question: *'What about perception?'* I had always completely taken for granted the answer to this question; so, although I can't claim to explain all the aspects that interest me, I thought I'd make a sideways, sort of drifty stab at responding to some parts of that question here.[1]

Inside out

I remember:

The colour of light on the harbour in Helsinki.

The warm grey of the sky in Berlin.

Dense heat and humidity in the Yucatan. Standing there, in a field, being drenched with rain that was warmer than even my skin.

Driving into a cloud of white butterflies, so large, so dense that it obscured all vision of the road and the sky.

A warm summer morning, bare feet, wet grass and the sound of sprinklers. Watching the light refract in the spray.

The glowing yellow light that streaks across my bedroom walls at 5:30 in the morning.

The sound of car tyres moving across an empty desert road on a hot summer night.

white blind (bright red)
2002
Mounted photographs
14 parts, each panel, 54 × 66.5 cm

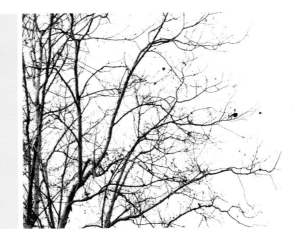

A cool night, bright moon, warm pool. Watching the steam rising.

The smell of the desert ground after a rainstorm.

Bare feet on warm sticky pavement. A Hollywood side street late one Saturday night.

Floating in a pool in the desert during a summer thunderstorm. Cool water falling on wet skin.

Looking into your eyes and the light reflecting in them. Looking past that light.

Something so far off in the distance, barely discernable, barely visible. Deep space.

Watching you walk away, walk into the dense rain. Watching your silhouette disappear into it.

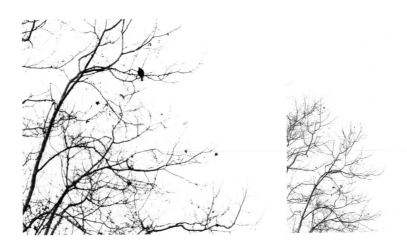

Artist's Writings

white blind (bright red)
2002
Mounted photographs
14 parts, each panel, 54 × 66.5
cm

The sudden feeling that someone is looking at you from behind.

Charcoal grey clouds moving towards me as I looked over your shoulder while we talked.

Squinting into piercing bright light. The look of the bleached and white landscape in Mexico.

Being on a fast train in Europe. A rainy landscape flying, streaking by in a flash of green.

The pale, slow fade of grey where the Glendale smog meets the sky.

Heat radiating, waving up from black asphalt, on a hot desert road. The smell of that.

A wall of water falling through the sky. Watching a storm in the distance.

The green glowing after-image of light caused by staring too hard and too long into a blinding, bright sky.

I remember each of these moments with a crystal clarity and completeness that even the present too often lacks. To this day I can see them, hear them; I can feel the humidity on my skin. Yet I remember little or nothing of the surrounding events.

Clearly these might be scenes that lend themselves neatly to romantic or melancholic interpretation – perhaps even nostalgia and longing? They would nicely set the tone for song lyrics that one might write ('*For you*'), or be the opening lines of a novel; after all they would all start with 'I remember', and each scene is quite solitary in nature. All the right stuff: what desire is made of. Since I am cursed with the capacity for pining, I might find this way of seeing *it* a useful one.

But …

But, perhaps, there is another way to look at this list (a list that could potentially continue *ad infinitum*.)

I assume all of us have such a list; but this one is mine.

Perhaps it exists because these are fragments of time when I was ripped from the flow of narrative into a single moment. A moment when sound and vision inverted themselves, tore inside out, and filled my attention to capacity. A moment when everything else dropped away and the experience of seeing, of sensing, became so overwhelming, so all-encompassing, that the very idea of interpretation did not, could not, exist.

This is an interesting space of mind: when we lose all assumed meaning; lose the inevitability of narrative; lose the impulse for interpretation. A space of mind that is dislodged from making meaning and yet sees beyond the 180 degrees before us.

This space of mind produces a strange kind of vision, where positive and negative space hold equal weight. Where you can see the air and hear the interval between the sounds of passing cars on a dark desert road late at night. Where rain is not a sign of longing but something that fills and articulates what was previously negative space. Where light and dark are not about mood, but blind and flood your field of vision.

white blind (bright red)
2002
Mounted photographs
14 parts, each panel, 54 × 66.5
cm

and, *"What are you doing?"*

Late one night, while writing his essay on *Untitled*, 1998, for this book, Jeremy Gilbert-Rolfe called to ask me: 'What is it you are doing before or when you are making these photographs?' The answer to this question is: I am doing absolutely nothing. I am not even lost in thought, but sort of lost in looking. I am quite literally doing what we call 'absentmindedly staring into space'. That is how I spend much of my time; it is incredibly unproductive and it wreaks havoc on my ever-looming work ethic. It is also a state of mind not given to the impulse of making photographs. To me, nothing about being suspended and engaged in the visual, auditory or sensory observation of the moment lends itself to the desire to freeze or save it. I don't have this type of relationship to making photographs, one of wanting to capture or replicate fleeting events. That would seem irrelevant and quite futile. The activity of making a photograph, to me, is one of disruption. The desire is not to capture or reproduce the moment, but perhaps, or hopefully, to create the potential for generating a new and quite different moment. Somehow the difference between these two desires seems an important distinction to me.

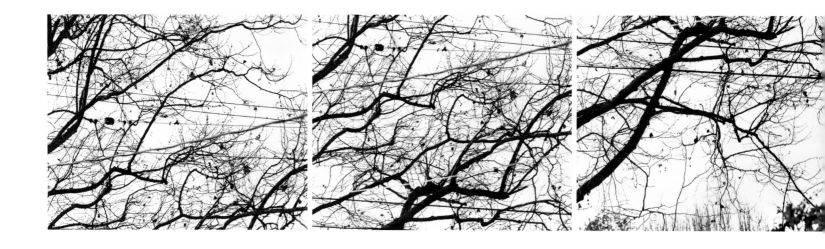

Again and again

Duration, endless repetition, sameness and redundancy, all for their own sake, are of interest here. Close attention which is not motivated by a developing story line. The scene does not change, but the raw impression of sight does with the blink of the eye. What happens when you stare into the light too long? The image burns onto your retina while its opposite drifts inside your eye and your mind. This 'drifting opposite' becomes the only event. An event worth watching, as it moves on its own and then recuperates and reconstitutes in the very next glimpse. It is not a narrative progression but a continual looping back to what is – almost – the original scene.

Scientists tell us that if you paralyze the eye and prevent it from moving continuously, scanning the scene much like a small motion detector, vision dissolves into a field of white light. They say that the eye *and* the brain only register difference and change. What is known and familiar is quite literally invisible. They also say that it is impossible to locate the point of distinction where the cells of the optic nerve turn into the cells of the brain.

Something about rain

'Is the work about being inside on a wet day?', Jeremy asks in his essay for this book.

In some ways, what could be better? And: *what else could it be?*
I've loved rainy weather all my life. Perhaps it is because I grew up with it in Berlin, a city wet and grey more often than not. But, more importantly, because watching the rain begin to fall on a scene outside a window slowly inverts all of the space before my eyes. Small drops, then streaks and lines begin to articulate what started out as the invisible volume of air: the negative space in the scene. My attention moves and my eyes begin to focus on a plane that was previously unoccupied, a plane in space that only seconds ago had no mark to guide the eye. In a short time, that which was empty fills with thick dense lines as it obscures what was previously *the view*. Wet blobs fill the volume to which everything else now becomes the backdrop. The glass of the

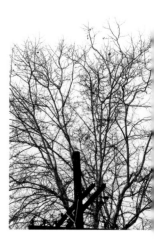

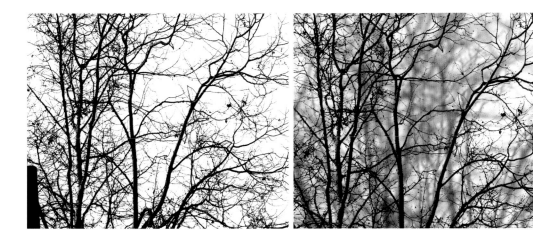

white blind (bright red)
2002
Mounted photographs
14 parts, each panel, 54 × 66.5
cm

window becomes a flat plane on which a screen of drops run and pour with increasing insistence and density, separating the two quite different events. All spatial understanding is reoriented. The ambient sound of raindrops falling is not directional but comes from all around. Their insistent sound repeatedly draws our attention to the present moment. This, it seems to me, is a pretty interesting thing to watch and listen to, from ' ... *the inside, on a wet day'*.

1 Martin, Timothy, *What about perception*, working title for a forthcoming collection of essays, some previously published in

 Uta Barth: In Between Places, Henry Art Gallery, University of Washington, Seattle, 2000.

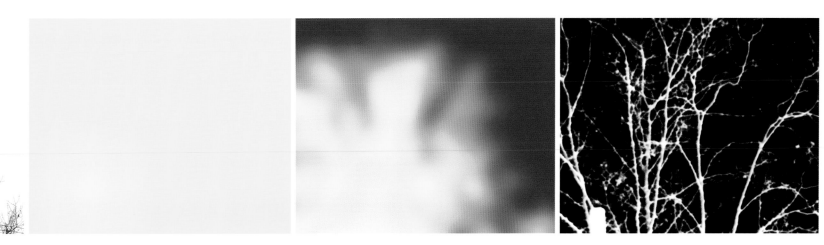

Contents

Interview Matthew Higgs in conversation with Uta Barth, page 6. Survey Pamela M. Lee

Uta Barth and the Medium of Perception, page 34 Focus Jeremy Gilbert-Rolfe Untitled (98.5), page 100.

Artist's Choice Joan Didion Democracy (extracts), 1984, page 110. Artist's

Writings Uta Barth Interview with Sheryl Conkelton, 1996, page 122. The Colour of Light in Helsinki, 2004,

page 136. Chronology page 144 & Bibliography, List of Illustrations, page 159.

Chronology Uta Barth Born 1958 in Berlin, lives and works in Los Angeles

Selected exhibitions and projects
1982–1989

1982
Studies, BA, University of California, Davis

'56th Annual Crocker Kingsly Exhibition',
E.B. Crocker Art Museum, Sacramento, California
(group)

'Five Photographers',
Joseph Dee Museum of Photography, San Francisco
(group)

1983–84
Award, National Arts Association

1984
Werkstadt fur Photographie, Berlin (group)

'Photography, Large Scale New Work',
Rex W. Wignal Museum Gallery, Alta Loma, California
(group)

1985
Studies, MFA, University of California, Los Angeles

Individual installation as part of Emerging Artists
Exhibition,
Frederick S. Wight Gallery, Los Angeles (solo)

Galleria by the Water, Los Angeles (solo)

'Uta Barth and Monique Safford',
Galleria by the Water, Los Angeles (solo)

1986
'Proof and Perjury',
Los Angeles Institute of Contemporary Art (group)

1987
'LAICA Artist Exhibition',
Los Angeles Institute of Contemporary Art (group)

University Art Gallery, University of California,
Riverside (group)

1989
'Deliberate Investigations: Recent Works by Four Los
Angeles Artists',
Los Angeles County Museum of Art (group)
Cat. *Deliberate Investigations: Recent Works by Four Los
Angeles Artists*, Los Angeles County Museum of Art,
texts Sheryl Conkelton, Kathleen Gauss

Selected articles and interviews
1982–1989

1985

French, David, 'Pick of the Week', *LA Weekly*, 17–23 May
Keledjian, Chris, 'Ironies and Contradictions', *Artweek*,
Palo Alto, 12 October

1986
Berland, Dinah, 'The Truth of Proof and Perjury', *Los
Angeles Times*, 6 October

1989
Pagel, David, 'Disposable Diagrams', *Artweek*, Palo
Alto, 14 October
Rugoff, Ralph, 'Remembering the Present:
Advertisements Against Our Own Amnesia', *LA Weekly*,
3–9 November
Gardner, Colin, 'Uta Barth at the Los Angeles County
Museum of Art', *Artforum*, No. 3, New York, November
Kandel, Susan, 'LA in Review: Deliberate
Investigations', *Arts Magazine*, New York, December
Knight, Christopher, 'Finding the Point of
"Deliberate"', *Los Angeles Herald Examiner*, 23 June
Curtis, Cathy, 'Photography Lies and Tricks Are Focus of
"Investigations"', *Los Angeles Times*, 23 October
Carlson, Lance, ' ... Or, Images of a Make-believe
Reality?', *Artweek*, Palo Alto, 30 September
Donohue, Marlena, 'Galleries/Reviews', *Los Angeles
Times*, 29 September
Marks, Ben, 'Reality Lies Somewhere In-between',
Santa Monica Bay News, 15–22 September

Selected exhibitions and projects
1989–92

Rio Hondo College Art Gallery, Whittier, California
(solo)

'Inland Empire Artist Exhibition',
San Bernardino County Museum of Art, Redlands,
California (group)

'Logical Conclusions',
Jan Kesner Gallery, Los Angeles (group)

Invitation card, Rio Hondo College Art Gallery, Whittier,
California

1990–91
National Endowment for the Arts, Visual Artist
Fellowship

1990
Appointed Professor, University of California,
Riverside, Department of Art, Riverside, California

Addison Gallery of American Art, Andover,
Massachusetts (solo)
Cat. *Uta Barth: Photographs; Jane Calvin: Reflection,
Recurrence – Rememory' Lorie Novak: Critiacal Distance*,
Addison Gallery of American Art, Andover,
Massachusetts, text Jim L. Sheldon

Howard Yezerski Gallery, Boston, Massachusetts
(solo)

'The Conceptual Impulse',
Security Pacific Gallery, Costa Mesa, California
(group)
Cat. *The Conceptual Impulse*, Security Pacific Gallery,
Costa Mesa, California, texts Mark Johnstone,
Benjamin Weissman

'Spirit of Our Time',
Contemporary Arts Forum, Santa Barbara, California
(group)

1991
'LA Times: Eleven Los Angeles Artists',
Boise Art Museum, Idaho, toured to **Western Gallery**,
Western Washington University, Bellingham,
Washington (group)
Cat. *LA Times: Eleven Los Angeles Artists*, Boise Art
Museum, Idaho, text Jacqueline S. Crist

1992–93
Awarded AMI Grant (Art Matters Inc., New York), Visual
Artist Fellowship

1992
'FAR Bazzar',
Foundation for Art Resources (FAR), Los Angeles
(group)

'Voyeurism',
Jayne Baum Gallery, New York (group)

UTA BARTH
JAN. 6 – FEB. 7

OPENING RECEPTION
SAT, JANUARY 6
3 PM THRU 5 PM

HOURS: TUES.–SAT. 10 AM TO 5:30 PM

UNTITLED #3 CONFIGURATION #2, 1988 ACRYLIC AND
BLACK AND WHITE PHOTOGRAPHS ON MASONITE 144x384¾"

HOWARD YEZERSKI GALLERY
186 SOUTH STREET BOSTON, MA 02111 · 617-426-8085

Selected articles and interviews
1989–92

Berland, Dinah, 'An Elegant, Graphic Photo Vision',
Long Beach Press Telegram, 26 February

Knight, Christopher, 'Narrative Puzzle to Please Eye',
Los Angeles Herald Examiner, 23 June

French, David, 'Uta Barth', *Visions: Art Quarterly*,
Visions 10, Vol. 3, No.3, Los Angeles, Spring

1990

Harbrecht, Gene, 'The Conceptual Impulse', *Orange
County Register*, 29 June
Curtis, Cathy, 'Brain Busters', *Los Angeles Times*, 28
June

Woodard, Josef, 'Spirit of Our Time', *Artweek*, Vol. 21,
No. 43, Palo Alto, 20 December
Crowder, Joan, 'Catching the Spirit of Our Time', *Santa
Barbara News Press*, 23 November

1991
Ross, Jeanette, 'Kicking Their Gurus', *Artweek*, Palo
Alto, 3 October
Spearman, Will, 'L.A. Artists Forego Glitz for Truth',
Idaho Statesman, Boise, 6 September

Howe, Graham; Perez, Pilar, 'Portfolio 1991 – Southern
California', *Frame/Work Magazine*, Vol 4., No. 3, Los
Angeles Center for Photographic Studies

1992

Aletti, Vince, 'Voice Choices: "Voyeurism"', *Village
Voice*, New York, 3 March

Selected exhibitions and projects
1993–94

1993
Artist project pages, *NOW Time*, Vol. 3, No. 1, Los Angeles, Summer

Artist project cover, *Picturebook*, Vol. 1, No. 2, Beverly Hills, Spring

S.P.A.S. Gallery, Rochester Institute of Technology, New York (solo)

'Index in French',
California Museum of Photography, Riverside (group)
Cat. *Index in French*, California Museum of Photography, Riverside, text Marilu Knode

'A Carafe, That Is a Blind Glass ... ',
Weingart Gallery, Los Angeles (group)
Cat. *A Carafe, That Is a Blind Glass ...*, Weingart Gallery, Los Angeles, text Amelia Jones

'P.O.P.: A Trilogy',
Susan Landau Gallery / 1529 Wellesley, Los Angeles (group)

1994–95
Awarded National Endowment for the Arts Visual Artist Fellowship

1994
'Uta Barth and Vikky Alexander',
domestic setting, Los Angeles (solo)

Wooster Gardens, New York (solo)

'The Abstract Urge'
The Friends of Photography's Ansel Adams Center, San Francisco (group
Cat. *The Abstract Urge*, The Friends of Photography's Ansel Adams Center, San Francisco, California, text Andy Grundberg

'Love In The Ruins',
Long Beach Museum of Art, California (group)
Cat. *Love In The Ruins*, Long Beach Museum of Art, California, text Noriko Gamblin

'Diverse Perspectives',
San Bernardino County Museum of Art, California (group)

'Breda Fotografica '94',
De Beyerd Centre of Contemporary Art, Breda, The Netherlands (group)
Cat. *Breda Fotografica '94*, De Beyerd Centre of Contemporary Art, Breda, The Netherlands, text Jean Ruiter

Selected articles and interviews
1993–94

1993

Artist project cover, *Picturebook*, Vol. 1, No. 2, Beverly Hills, Spring

Anderson, Michael, '"A Carafe, That is a Blind Glass" and "Sugar 'n' Spice"', *Art Issues*, Los Angeles, May–June
Pagel, David, 'Smart and Sensuous', *Los Angeles Times*, 4 March
Timothy Nolan, 'Reading Lessons', *Artweek*, Vol. 24, No. 7, Palo Alto, 8 April

Tumlir, Jan, 'Homebodies: P.O.P. at 1529 Wellesley', *Artweek*, Vol. 24, No. 6, Palo Alto, 18 March

1994
Jones, Amelia, 'Uta Barth at domestic setting', *Art Issues*, No. 35, Los Angeles, November–December
Munchnic, Suzanne, 'Uta Barth and Vikky Alexander', *ARTnews*, New York, November

Hagen, Charles, 'Review: Wooster Gardens', *New York Times*, 28 January

Rogers, Michael, 'Love and Art amid the Ruins of California's Paradise Lost', *Orange County Register*, 11 March
Joyce, Julie, 'Images of Anywhere', *Artweek*, Vol. 25, No. 16, Palo Alto, 18 August
Pagel, David, 'Life's Intermissions', *Los Angeles Times*, 28 July

Selected exhibitions and projects
1994–95

'Diterot and the Last Luminare, Waiting for the
Enlightenment (A Revised Encyclopedia) or The Private
Life of Objects',
Southern Exposure at Project Artaud, San Francisco,
toured to **SITE**, Los Angeles (group)
Cat. *Diterot and the Last Luminare, Waiting for the
Enlightenment (A Revised Encyclopedia) or The Private
Life of Objects*, Southern Exposure at Project Artaud,
San Francisco, text Erika Suberg

'The World of Tomorrow',
Tom Solomon's Garage, Los Angeles (group)

Jayne Baum Gallery, New York (group)

1995
Awarded AMI Grant (Art Matters Inc., New York), Visual
Artist Fellowship

Museum of Contemporary Art, Los Angeles (solo)
Book, *At the Edge of the Decipherable: Recent
Photographs by Uta Barth*, Museum of Contemporary
Art, Los Angeles/RAM, Publications, text Elizabeth A.T.
Smith

ACME., Santa Monica, California (solo)

Tanya Bonakdar Gallery, New York (solo)

'New Photography 11',
The Museum of Modern Art, New York (group)

'P.L.A.N.',
Los Angeles County Museum of Art (group)
Cat. *P.L.A.N.*, Los Angeles County Museum of Art, texts
Robert Sobiezak, Tim Wride

Covers, *At the Edge of the Decipherable: Recent Photographs
by Uta Barth, top* 1995 edition, *bottom* 2002 reprint

'Human/Nature',
The New Museum, New York (group)

'Diverse Perspectives',
San Bernardino County Museum of Art, California
(group)

Selected articles and interviews
1994–95

Frank, Peter, 'Pick of the Week: "The World of
Tomorrow"', *LA Weekly*, 3 March
Pagel, David, 'Taking A Glimpse Into "The World of
Tomorrow"', *Los Angeles Times*, 24 February

Aletti, Vince, 'Voice Choice', *Village Voice*, New York, 28
July
Aletti, Vince, 'Voice Choice', *Village Voice*, New York, 3
August

1995

Zellen, Jody, 'What is a Geographical Space? Uta
Barth: ACME., MoCA, Los Angeles', *artpress*, Paris,
January 1996
Pedrosa, Adriano, 'Uta Barth: Museum of
Contemporary Art, Los Angeles', *frieze*, London, May
1996
Rugoff, Ralph, 'Smear Tactics', *LA Weekly*, 20–26
October
Green, David A., 'Warm and Fuzzy: For Photographer
Uta Barth, All the World's a Blur', *Los Angeles Reader*, 3
November

Kandel, Susan, 'Uta Barth', *Art and Text*, No. 52,
Sydney, September
Knight, Christopher, 'Art in All the Right Spaces', *Los
Angeles Times*, 21 September

Decter, Joshua, 'Uta Barth at Tanya Bonakdar Gallery',
Artforum, New York, April
Hapgood, Susan, 'Uta Barth at Tanya Bonakdar
Gallery', *Art in America*, No. 5, New York, May
Schwendener, Martha, 'Uta Barth at Tanya Bonakdar
Gallery', *New Art Examiner*, Chicago, April
Aletti, Vince, 'Voice Choices', *Village Voice*, New York,
14 February

Aletti, Vince, 'New Photography 11', *Village Voice*, New
York, 7 November
Brisley, C.B., 'MoMA: New Photography 11', *artpress*
No. 209, Paris, January 1996

Selected exhibitions and projects
1995–96

'Sitting Pretty',
Los Angeles Contemporary Exhibitions (group)

'From Here to There: Tactility and Distraction',
California Medical Arts, Santa Monica (group)

Rena Bransten Gallery, San Francisco (group)

1996
Tanya Bonakdar Gallery, New York (solo)

London Projects, London (solo)

S.L. Simpson Gallery, Toronto (solo)

Rena Bransten Gallery, San Francisco (solo)

Artist's project, 'Artist Project: Field 1996', *Blind Spot*,
No. 7, New York

Artist's project, *Art & Design: Art & The Home*, No. 11,
London, November–December, with text 'Undoing
Space' by Soo Jin Kim

'Just Past: The Contemporary in the Permanent
Collection, 1975–96',
Museum of Contemporary Art, Los Angeles (group)

'Painting: The Extended Field',
Rooseum: Centre for Contemporary Art, Malmo;
Magasin 3 Stockholm Konsthall, Stockholm (group)
Cat. *Painting: The Extended Field*, Rooseum: Centre for
Contemporary Art, Malmo/Magasin 3 Stockholm
Konsthall, texts Sven-Olov Wallenstein, David
Neuman, Bo Nilsson

UTA BARTH

14 June–27 July, 1996
Preview: Thursday 13 June, 6-8pm

LONDONPROJECTS
47 Frith Street
London W1V 5TE
Tel 0171 734 1723
Fax 0171 494 1722
Friday and Saturday 10am–6pm or by appointment

Invitation card, Rena Bransten Gallery, San Francisco

Selected articles and interviews
1995–96

Hagen, Charles, 'Found Photographs and Chance:
Serendipity', *New York Times*, 27 October
Jan, Alfred, 'Barth, Casebere, Gursky, Hoffer, Welling:
Five Artists Honor the Integrity of the Photograph',
ArtistWriter, Vol. 4., No. 9, San Francisco,
November–December

Knöde, Marilu, 'Uta Barth in Conversation with Marilu
Knode', *Artlies Contemporary Art Magazine*, No. 7,
June–July
Brun, Donatella, 'Regards: Uta Barth', *Jardin des
Modes*, Paris, Autumn
Fiskin, Judy, 'Trope l'Oeil for Our Time', *Art Issues*, No.
40, Los Angeles, November–December

1996

Thrift, Julia, 'Uta Barth', *Time Out*, London, 15–24 July

Van de Walle, Mark, 'Uta Barth at Tanya Bonakdar',
Artforum, New York, September
Jordan, Betty Ann, 'Uta Barth and Michael Snow at S.L.
Simpson', *Globe*, Toronto, 2 November
Folland, Tom, 'Uta Barth: S.L. Simpson Gallery',
Parachute, No.86, Montreal, Spring 1997

Simpson, Rebecca, 'Flirting with Reality, MoCA
Exhibition Explores Transitions of Photographs,
Paintings', *Sun Post*, Chicago, 26 December

Altgård, Clemens, 'De sju provokatörerna', *Sydsvenska
Dagbladet*, Malmo, 8 October
Arrhenius, Sara, 'Död eller', *Aftonbladet*, Stockholm,
16 October
Birnbaum, Daniel, 'Måleri i nya skepnader', *Dagens
Nyheter*, Stockholm, 15 October
Castenfors, Mårten, 'Rätt avslöjande av måleriets
klyschor', *Svenska Dagbladet*, Malmo, 19 October
Corlin, Elisabet, 'The Extended Field', *När & Var
Magazine*, Stockholm, 15 November–1 February
1996–97
Kempe, Jessica, 'Klargörande som tidsuttryck-
nollgradig som konstupplevelse', *Dagens Nyheter*,
Stockholm, 15 October
Klinthage, Jörgen, 'På jakt efter bilder Måleriet som
utvidgat fält på Rooseum i Malmö', *Hallands-posten*,
Stockholm, 28 October
Madestrand, Bo, 'Humla utan båt?', *Expressen*, 16
October

Selected exhibitions and projects
1996

'Light · Time · Focus',
Museum of Contemporary Photography, Chicago
(group)

'Wrestling with the Sublime: Contemporary German Art
in Southern California',
Main Art Gallery, Cal State Fullerton, Fullerton,
California (group)

'Absence',
Guggenheim Gallery, Chapman University, Orange,
California (group)
Cat. *Paper of Plastic: On the Production of Absence*,
Guggenheim Gallery, Chapman University, California,
text D.H. Bailey

'Clarity',
NIU Art Gallery, Northern Illinois University, Chicago
(group)
Cat. *Clarity*, Northern Illinois University Art Galley,
Chicago, text Grant Samuelsen

'Making Pictures: Women and Photography,
1975–Now',
Nicole Klagsbrun, New York (group)

'Portraits of Interiors',
Studio la Città, Verona, Italy (group)
Cat. *Portraits of Interiors*, Studio la Città, Verona, Italy,
text Peter Weiermair

'silence',
Lawing, Houston, Texas (group)

'… e la chiamano pittura',
Studio la Città, Verona, Italy (group)
Cat. *… e la chiamano pittura …*, Studio la Città, Verona,
Italy, text Mario Bertoni

'Paper or Plastic: On the Production of Absence',
Guggenheim Gallery, Chapman University, Orange,
California (group)
Cat. *Paper or Plastic: On the Production of Absence*,
Guggenheim Gallery, Chapman University, Orange,
California, text D.H. Bailey

Selected articles and interviews
1996

Malmqvist, Conny C-A, 'Ryktet om måleriets död är
betydligt överdrivet', *Kväusposten*, Stockholm, 20
October
Nanne-Bråhammar, Marianne, 'Måleri är inte bara…
Nya utvecklingstendenser på Rooseum', *Arbetet
Nyueterna*, Stockholm, 20 October
Zeylon, Håkan, 'Ger en känsla av frånvaro', *Sydsvenska
Dagbladet*, Malmo, 8 October
Wachholz, Helga, 'Belebung und Erneuerung der
Malerei?', *Handelsblat*, Dusseldorf, 23 November
Waltenberg, Lilith, 'Måleriet har hittat nya vägar',
Sydsvenska Dagbladet, Malmo, 6 October
Orstadius, Brita, 'Rooseum: En mjuk provokation',
Borås Tining, Stockholm, 11 November

Camper, Fred, 'Focus on the Invisible', *Chicago Reader*,
Vol. 25, No. 26, 5 April
Foerstner, Abigail, 'Altered Perception', *Chicago
Tribune*, 12 May

Curtis, Cathy, 'Filling The "Absence"', *Los Angeles
Times*, 4 April

Hixon, Katheryn, 'Clarity', *New Art Examiner*, Chicago,
May

Aletti, Vince, 'Voice Choice: Making Pictures: Women
and Photography, 1975–Now', *Village Voice*, New York,
19 November

Weiermair, Peter, 'Portraits of Interiors', *Studio la
Citta*, Verona, September

Dewan, Sheila, 'Quiet Please', *Houston Press*, 3–9
October
Johnson, Patricia C., 'Communication, Or Lack of It, Is
Exhibits' Theme', *Houston Chronicle*, 20 September

Gilbert-Rolfe, Jeremy, 'Cabbages, Raspberries and
Video's Thin Brightness', *Art & Design, Painting in the
Age of Artificial Intelligence*, Vol. 11, Nos. 5–6, London,
May–June

Selected exhibitions and projects

1997

1997
'The Wall Project',
Museum of Contemporary Art, Chicago (solo)

Presentation House Gallery, North Vancouver, Canada
(solo)

Institute of Contemporary Art at MCA, Portland,
Maine (solo)

' ... in passing',
ACME., Santa Monica, California (solo)

Andréhn-Schiptjenko, Stockholm (solo)

Rena Bransten Gallery, San Francisco (solo)

'Heart, Mind, Body, Soul: American Art in the 1990s',
Whitney Museum of American Art, New York (group)

'Object and Abstraction: Contemporary Photography',
The Museum of Modern Art, New York (group)

'Blueprint',
De Appel Foundation, Amsterdam (group)
Cat. and audio CD, *Blueprint*, De Appel Foundation,
Amsterdam, texts Pierre Bismuth, Saskia Bos, Hans
den Hartog Jager

'Spheres of Influence',
Museum of Contemporary Art, Los Angeles (group)

'Painting into Photography/Photography into
Painting',
Museum of Contemporary Art, Miami, Florida (group)
Cat. *Painting into Photography/Photography into
Painting*, Museum of Contemporary Art, Miami, texts
Bonnie Clearwater

'Evidence: Photography and Site',
Wexner Center for the Arts, Columbus, Ohio, toured to
Cranbrook Art Museum, Bloomfield Hills, Missouri;
The Power Plant, Toronto; **Miami Art Museum**, Florida
(group)
Cat. *Evidence: Photography and Site*, Wexner Center for
the Arts, texts Sarah J. Rogers, Mark Robins, Lynne
Tillman

'Scene of the Crime',
Armand Hammer Museum of Art, Los Angeles (group)
Cat. *Scene of the Crime*, Armand Hammer Museum of
Art, Los Angeles/MIT Press, Cambridge,
Massachusetts, texts Anthony Vidler, Peter Wollen,
Ralph Rugoff

'Defining Eye: Women Photographers of the Twentieth
Century',
St. Louis Art Museum, Missouri, toured to **Mead Art
Museum**, Amherst College, Massachusetts; **Wicheta
Art Museum**, Kansas; **UCLA Hammer Museum**, Los
Angeles; **The National Museum of Women in the Arts**,
Washington, DC (group)
Cat. *Defining Eye: Women Photographers of the 20th
Century*, St. Louis Art Museum, Missouri, texts Lucy
Lippard, Olovia Lahs-Gonzales

Invitation card, 'The Wall Project', Museum of Contemporary
Art, Chicago

Selected articles and interviews

1997

1997
Stament, Bill, 'Uta Barth, "Field #20" and "Field
#21"', *Chicago Sun Times*, 25 June

Scott, Michael, 'Backgrounds Come to the Fore',
Vancouver Sun, 19 April

Princenthal, Nancy, 'Uta Barth ... In Passing', *Art on
Paper*, Vol. 1, No. 2, New York, November–December
1996

Invitation card, Rena Bransten Gallery, San Francisco

Koeniger, Kay, 'Photographs Document Human Places
Mostly by Leaving People Out', *Columbus Dispatch*, 23
March

Knight, Christopher, 'There is Evidence of Good Work
Found at "Scene of Crime"', *LA Times*, 29 July
LaBelle, Charles, 'Scene of the Crime', *World Art*, No.
16, Melbourne, 1998

Rugoff, Ralph, 'L.A.'s Female Art Explosion', *Harper's
Bazaar*, New York, April

Selected exhibitions and projects
1997–98

'Coda: Photographs by Uta Barth, Günther Forg, Jack
Pierson and Carolien Stikker',
Center for Curatorial Studies, Bard College,
Annandale-on-Hudson, New York (group)

'Uta Barth, Jean Baudrillard, Luigi Gherri',
Parco Gallery, Tokyo (group)
Cat. *Uta Barth, Jean Baudrillard, Luigi Gherri*, Parco
Gallery, Tokyo

'The Citibank Private Bank Photography Prize 1997',
Royal College of Art, London (group)
Cat. *The Citibank Photography Prize*, Citibank, texts
Richard Cork, Paul Wombell, Tessa Trager

'Digital Ink: Uta Barth, Peter Halley, William Leavitt,
James Welling',
Center for Visual Communication, Coral Gables,
Florida (group)

'Uta Barth, Rineke Dijkstra, Tracy Moffatt, Inez van
Lamsweerde',
Matthew Marks Gallery, New York (group)

'Light Catchers',
Bennington College Art Gallery, Vermont (group)

Tanya Bonakdar Gallery, New York (group)

'Twenty Years ... Almost',
Robert Miller Gallery, New York (group)

'Passing the Tradition: California Photography',
Jose Druidis – Bida Art Gallery, Los Angeles (group)

'Portraits of Interiors',
Gallery Blancpain Stepczynski, Geneva (group)

'LA International Biennial: "Portraits of Interiors"',
Patricia Faure Gallery, Santa Monica, California
(group)

'Grands Maîtres du Xxéme',
Galerie Verdovi, Brussels (group)

1998
ACME., Los Angeles (solo)

Selected articles and interviews
1997–98

Aletti, Vince, 'Uta Barth/Rineke Dijkstra/Tracey
Moffatt/Inez van Lamsweerde', *Village Voice*, New York,
25 July

Meneghelli, Luigi, 'Portraits of Interiors', *Flash Art*,
Milan, February–March
Pagel, David, 'Inside Jobs: Portraits of Interiors', *Los
Angeles Times*, 1 August

Kandel, Susan, 'Pointed Images', *Los Angeles Times*, 27
June
Wolf, Silvio, 'Le Rangioni della Nuova: Fotofraphia
Analogica', *Tema Celeste*, Milan, March–April
Willette, Jeanne S.M., 'Reinventing Photography;
"Photography as Commentary: The Camera (Obscura)
and Post-Philosophical Systems"', *Artweek*, Vol. 28,
No. 7, Palo Alto, July
Levin, Kim; Aletti, Vince, 'Our Biennial', *Village Voice*,
New York, 21 January
Conkelton, Sheryl, 'Uta Barth', *Journal of
Contemporary Art*, Vol. 8, No. 1, New York, Summer
Surface: Contemporary Photographic Practice, eds.
Simon Browning, Michael Mack, Sean Perkins,
afterword by Michael Mack; Booth-Clibborn Editions,
London

1998
Tumlir, Jan, 'Uta Barth: ACME, Los Angeles', *Art & Text* ,
No. 62, Sydney, August–September

Selected exhibitions and projects
1998

Bonakdar Jancou Gallery, New York (solo)

Lawing, Houston, Texas (solo)

London Projects, London (solo)

'Uta Barth and Imi Knoebel',
Studio la Città, Verona, Italy (solo)

'Abstract Painting, Once Removed',
Museum of Contemporary Art, Houston, Texas, toured
to **Kemper Museum of Contemporary Art**, Kansas City,
Missouri; **Museum of Contemporary Art**, Chicago,
Illinois; **Albright-Knox Art Gallery**, Buffalo, New York
(group)
Cat. *Abstract Painting, Once Removed*, Contemporary
Arts Museum, Houston, texts David Pagel, Raphael
Rubenstein, Peter Schjeldahl, Dana Friis-Hansen

'Claustrophobia',
IKON Gallery, Birmingham, England, toured to
Middlesbrough Art Gallery; Harris Museum, Preston;
Mapping Art Gallery, Sheffield; **Cartwright Hall**,
Bradford; **Esbjerg Kunstmuseum**, Denmark; **Centre
for Visual Arts**, Cardiff (group)
Cat. *Claustrophobia*, IKON Gallery, Birmingham,
England, texts Claire Doherty, Soo JinKim

'Photography's Multiple Roles: Art, Documents,
Market, Science',
Museum of Contemporary Photography, Chicago
(group)
Cat. *Photography's Multiple Roles: Art, Documents,
Market, Science*, Museum of Contemporary
Photography, Chicago/Distributed Art Publishers Inc.,
New York, texts Denise Miller, et al.

'Undere/Exposed',
Public Art Project, Stockholm (group)
Cat. *Undere/Exposed*, Kulturhuvudstad, Stockholm,
text Christian Caujolle

'Xposeptember',
FotoFestival Stockholm
Cat. *Xposeptember*, FotoFestival Stockholm, text Carl
Heidiken

FotoFest 98: The Seventh International Festival of
Photography,
Rice University, Houston, Texas (group)
Cat. *FotoFest 98: The Seventh International Festival of
Photography*, Rice University, Houston, Texas

'Mysterious Voyages',
Tanya Bonakdar Gallery, New York (group)

'LA Cool',
Rocket Gallery, London (group)

'Spread',
Rena Bransten Gallery, San Francisco (group)

Selected articles and interviews
1998

Diehl, Carol, 'Uta Barth at Bonakdar Jancou', *Art in
America*, New York, October
Perchuk, Andrew, 'Uta Barth: Bonakdar Jancou
Gallery', *Artforum*, New York, September

Currah, Mark, 'Uta Barth, London Projects', *Time Out*,
London, 14–21 October
Exley, Roy, 'Uta Barth: London Projects', *Zing
Magazine*, London, Winter

Mahoney, Elizabeth, 'Claustrophobia', *Art Monthly*,
London, July–August
Grimley, Terry, 'Haunting Art from the Kosovo
Frontline', *Birmingham Post*, 10 June

Thrift, Julia, 'LA Cool', *Time Out*, London, 20–27 May

Jana, Reena, '"Spread" at Rena Bransten', *Flash Art*,
Milan, October

Selected exhibitions and projects
1998–99

Bonakdar Jancou Gallery, New York (group)

'Situacionismo',
Galeria OMR, Mexico City (group)

1999
'nowhere near' (part one),
ACME., Los Angeles (solo)
Artist's book, *nowhere near*, self published, text Jan
Tumlir

'nowhere near' (part two),
Bonakdar Jancou Gallery, New York (solo)

'nowhere near' (part three),
Andréhn-Schiptjenko, Stockholm (solo)

Rena Bransten Gallery, San Francisco (solo)

Galerie Camargo Vilaça, Sao Paulo, Brazil (solo)

Artist project, 'Artist Project: " … and of time."', *Blind
Spot*, No. 15, New York, Spring–Summer

'Photography: An Expanded View, Recent
Acquisitions',
Solomon R. Guggenheim Museum, New York (group)

'Apposite Opposites',
Museum of Contemporary Art, Chicago (group)

'Threshold: Invoking the Domestic in Contemporary
Art',
John Michael Kohler Arts Center, Sheboygan,
Wisconsin, toured to **Contemporary Art Center of
Virginia** (group)
Cat. *Threshold: Invoking the Domestic in Contemporary
Art*, John Michael Kohler Arts Center, Sheboygan,
Wisconsin, text Andrea Inselmann

'double vision',
Nexus Contemporary Art Center, Atlanta, Georgia
(group)
Cat. *double vision*, Nexus Contemporary Art Center,
Atlanta, Georgia, texts Michael Pittari

'Umeå kommuns konstinköp under 90-talent i urval',
Umeå Bildsmuseum, Sweden (group)
Cat. *Xets KOFTA: Umeå kommuns konstinköp under 90-
talent i urval*, Umeå Bildsmuseum, Sweden, texts Inge-
bert Täljedal, et al.

'Conceptual Art as Neurobiological Praxis',
Thread Waxing Space, New York (group)

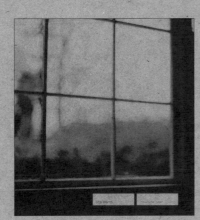

Cover, artist's book, *nowhere near*, self published

Selected articles and interviews
1998–99

Aletti, Vince, 'Voice Choices', *Village Voice*, New York,
15–21 April
Aletti, Vince, 'Voice Choices', *Village Voice*, New York,
31 March
Johnson, Ken, 'Art Guide', *New York Times*, 17 April

Grabner, Michelle, 'Fuzzy Logic', *Cakewalk*, No. 1, Los
Angeles, Spring–Summer

1999
McGovern, Thomas, 'Uta Barth at ACME.', *Artweek*, Vol.
31, No. 1, Palo Alto, January 2000
Labelle, Charles, 'Uta Barth : ACME Gallery, Los
Angeles', *Art & Text* , No. 68, Sydney, February–April
2000
Pagel, David, 'Space Exploration', *Los Angeles Times*,
22 October

Sundell, Margaret, 'Uta Barth at Bonakdar Jancou',
Artforum, New York, January 2000
Aletti, Vince, 'Voice Choice', *Village Voice*, New York, 23
November

Boxer, Sarah, 'The Guggenheim Sounds Alarm: It Ain't
Necessarily So', *New York Times*, 19 March

Selected exhibitions and projects
1999–2000

2000
'In Between Places',
Henry Art Gallery, University of Washington, Seattle;
Contemporary Art Museum, Houston, Texas (solo)
Cat. *In Between Places*, Henry Art Gallery, University of
Washington, Seattle/Distributed Art Publishers Inc.,
New York, texts Uta Barth, Sheryl Conkelton, Russel
Ferguson, Timothy Martin

'nowhere near',
Lannan Foundation, Santa Fe, New Mexico (solo)

'nowhere near',
Johnson County Community College Gallery of Art,
Overland Park, Kansas (solo)

'Departures: 11 Artists at the Getty',
The J. Paul Getty Museum, Los Angeles (group)
Cat. *Departures: 11 Artists at the Getty*, The J. Paul Getty
Museum, Los Angeles, text Lisa Lyons
Artist's book, *… and of time*, self published, text
Timothy Martin

'Tate Modern: Ten Artists, Ten Images',
Tate Modern, London (group)

'In-sites: Interior Spaces in Contemporary Art',
Whitney Museum of American Art at Champion,
Champion, Connecticut (group)

'Imperfectum',
organized by Riksutstillinger: National Touring
Exhibitions,
Museet for Samtidskunst, Oslo, toured to **Rogaland
Kunstmuseum** Stavanger, Norway; **Trondheim
Kunstmuseum**, Norway; **Fylkesgalerie**, Namsos,
Norway; **Bomullsfabrikken**, Arendal, Norway;
Billedgalerie, Haugesund, Norway; **Bodo
Kunstforening**, Bodo, Norway; **Aalesunds
Kunstforening**, Aalesund, Norway (group)
Cat. *Imperfectum*, Riksutstillinger: National Touring
Exhibitions, Norway, text Jan Brokman

'Photography Now',
Contemporary Arts Center, New Orleans, Louisiana
(group)
Cat. *Photography Now*, Contemporary Arts Center, New
Orleans, Louisiana

Invitation card, 'In Between Places', Henry Art Gallery,
University of Washington, Seattle

Invitation card, 'nowhere near', Johnson County Community
College Gallery of Art, Overland Park, Kansas

Selected articles and interviews
1999–2000

Clearwater, Bonnie, 'Slight of Hand: Photography in
the 1990s', *Art Papers*, Atlanta
Exley, Roy, 'New Abstract Photography: Towards
Abstraction, the Painterly Photograph', *Creative
Camera*, No. 358, London, June–July
Gilbert-Rolfe, Jeremy, *Beauty and the Contemporary
Sublime*, Allworth Press, London
Johnstone, Mark, *Contemporary Art in Southern
California*, Craftsman House

2000

Catalogue cover, *In Between Places*, Henry Art Gallery, University of
Washington, Seattle/Distributed Art Publishers Inc., New York

Harvey, Doug, 'Mounds: Monumental Edibles at the
Getty Contemporary', *LA Weekly*, 10–16 March

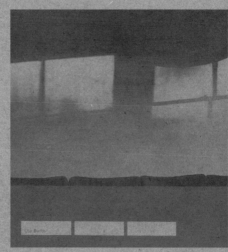

Cover, artist's book, *… and of time*, self published

Bowen, Dore, 'RATTLE & ROLL. Rattling the Frame: The
Photographic Space 1974–1999', *Afterimage*, Vol. 27,
No. 5, Rochester, New York, March
Pagel, David, *CAArt: Themes Out of School*, Creative
Artists Agency, The CAA Foundation
Blazwick, Iwona, 'Uta Barth', *FRESH CREAM*, Phaidon
Press, London

Selected exhibitions and projects
2000–02

2001
'Uta Barth 1991–94',
Lawing Gallery, Houston, Texas (solo)

2002
Artist project, 'Untitled, 2002, Installation Project',
Blind Spot, No. 22, New York

'white blind (bright red)'
Tanya Bonakdar Gallery, New York (solo)

'white blind (bright red)'
ACME., Los Angeles (solo)

'Visions of America: Photography from the Whitney
Museum of American Art 1940–2001',
Whitney Museum of American Art, New York (group)
Cat. *Visions of America: Photography from the Whitney
Museum of American Art 1940–2001*, Whitney Museum
of American Art, New York, texts Sylvia Wolf, Andy
Grundberg, Sondra Gilman Gonzalez-Fella

'History/Memory/Society: Displays from the
Permanent Collection',
Tate Modern, London (group)

'Looking at America',
Yale University Art Gallery, New Haven, Connecticut
(group)

'Global Address',
Fisher Gallery, University of Southern California, Los
Angeles (group)
Cat. *Global Address*, Fisher Gallery, University of
Southern California, Los Angeles

'<Stepping Back, Moving Forward> Human Interaction
in an Interactive Age',
Pittsburgh Center for the Arts, Pennsylvania (group)

Selected articles and interviews
2000–02

Varnedoe, Kirk; Antonelli, Paolo; Siegel, Joshua
(eds.), *Modern Contemporary: Art At MOMA Since 1980*,
The Museum Of Modern Art, New York

2001
Johnson, Patricia C., 'Uta Barth Focuses on Changing
Perceptions', *Houston Chronicle*

Kornbluth, Elena, 'Triple Exposure, Three
Photographers in Focus, Sam Tayor-Wood, Uta Barth,
Jessica Craig-Martin', *ELLE DÉCOR*, No. 81, New York,
February–March
Lowery, Glen, 'Recontre Avec Uta Barth: Cham Libre',
Connaissance Des Arts, No. 586, Paris, September

2002

Burton, Johanna, 'Uta Barth', *Time Out New York*, 7–14
November
Martegani, Micaela, 'Uta Barth: Tanya Bonakdar
Gallery, New York', *Tema Celete*, Milan,
January–February 2003

Meyers, Holly, 'Loaded Questions amid the Treetops',
Los Angeles Times, 25 October

Martin, Victoria, '"Global Address" at USC Fisher
Gallery', *Artweek*, Vol. 22, No. 3, Palo Alto, April
Kidera, Inga, 'Home is Where the Art Is', *Chronicle*, USC
publication, Los Angeles

Wolf, Silvia, *Michael Rovner: The Space Between*,
Whitney Museum of American Art, New York
Kertess, Klauss, *Photography Transphormed*, The
Metropolitan Mank and Trust Collection, Harry N.
Abrams, New York
Warner Marien, Mary, *Photography: A Cultural History*,
Laurence King Publishing, London; Harry N. Abrams,
New York
Blink: 100 Photographers, 010 Curators, 010 Writers,
Phaidon Press, London

Selected exhibitions and projects
2003–05

2003
'white blind (bright red)',
Andréhn-Schiptjenko, Stockholm (solo)

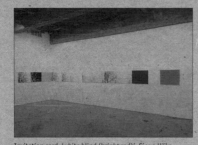

'white blind (bright red)',
Sies + Höke Galerie, Dusseldorf (solo)

'Imperfect Innocence: The Debra and Dennis Scholl
Collection',
Contemporary Museum, Baltimore; **Palm Beach
Institute of Contemporary Art** (group)
Cat. *Imperfect Innocence: The Debra and Dennis Scholl
Collection*. Palm Beach Institute of Contemporary Art,
Lake Worth, Florida, texts by Nancy Spector, James
Rondeau, Michael Rush

Invitation card, 'white blind (bright red)', Sies + Höke
Galerie, Dusseldorf

'Moving Pictures: Contemporary Photography and
Video from the Guggenheim Museum Collection',
Solomon R. Guggenheim Museum, New York, toured
to **Guggenheim Bilbao** (group)
Cat. *Moving Pictures: Contemporary Photography and
Video from the Guggenheim Museum Collection*,
Solomon R. Guggenheim Museum, New York, texts
Nancy Spector, John Hanhardt

'Public Record',
Museum of Contemporary Art, Los Angeles (group)

'Beside',
ACME., Los Angeles (group)

2004
Rena Bransten Gallery, San Francisco (solo)

Nominated for Smithsonian Lucelia Award

Awarded John Simon Guggenheim Memorial
Foundation's Guggenheim Award

'From House to Home: Picturing Domesticity',
Museum of Contemporary Art, Los Angeles (group)

'Landscape',
Rena Bransten Gallery, San Francisco (group)

2005
'white blind (bright red)',
Site Santa Fe, New Mexico (solo)
Cat. *white blind (bright red)*, Site Santa Fe, 2004, text
Jan Tumlir

Tanya Bonakdar Gallery, New York (solo)

ACME., Los Angeles (solo)

Andrehn Schipjenko, Stockholm (solo)

Sies + Höke, Dusseldorf (solo)

Site-specific project, IT house, Los Angeles/New York

Selected articles and interviews
2003–05

2003
Nilsson, Håkan, 'Vardagens svit', *Dagens Nyheter*,
Stockholm, 31 May
Alton, Peder, 'Rum som musik', *Dagens Nyheter*, *På
Stan*, Stockholm, 6 June
Olofsson, Anders, 'Andréhn-Schiptjenko, Stockholm:
Uta Barth (8/5 – 7/6)', www.konsten.net, May

Campany, David, (ed.), *Art and Photography*, Phaidon
Press, London

white blind (bright red) uta barth

Cover, *white blind (bright red)*, Site Santa Fe, 2004

Aletti, Vince, 'Voice Choices', *Village Voice*, New York, 14 February 1995

Aletti, Vince, 'Uta Barth/Rineke Dijkstra/Tracey Moffatt/Inez van Lamsweerde', *Village Voice*, New York, 25 July 1997

Aletti, Vince, 'Voice Choice', *Village Voice*, New York, 23 November 1999

Alton, Peder, 'Rum som musik', *Dagens Nyheter, På Stan*, Stockholm, 6 June 2003

Antonelli, Paolo; Siegel, Joshua; Varnedoe, Kirk (eds.), *Modern Contemporary: Art at MoMA Since 1980*, The Museum of Modern Art, New York, 2000

Barth, Uta, artist's project, cover, *Picturebook*, Vol. 1, No. 2, Beverly Hills, Spring 1993

Barth, Uta, artist's project pages, *NOW.Time*, Vol. 3, No. 1, Los Angeles, Summer 1993

Barth, Uta, *At the Edge of the Decipherable: Recent Photographs by Uta Barth*, Museum of Contemporary Art, Los Angeles/RAM, Publications, 1995

Barth, Uta, artist's project, 'Artist Project: Field 1996', *Blind Spot*, No. 7, New York, 1996

Barth, Uta, artist's project, *Art & Design: Art & The Home*, No. 11, London, November–December 1996

Barth, Uta, artist's project, 'Artist Project: " ... and of time."', *Blind Spot*, No. 15, New York, Spring–Summer 1999

Barth, Uta, *nowhere near*, self-published artist's book, 1999

Barth, Uta, *In Between Places*, Henry Art Gallery, University of Washington, Seattle/Distributed Art Publishers Inc., New York, 2000

Barth, Uta, *... and of time*, self-published artist's book, 2000

Barth, Uta, artist's project pages, 'Untitled, 2002, Installation Project', *Blind Spot*, No. 22, New York, 2002

Barth, Uta, *white blind (bright red)*, Site Santa Fe, 2004

Blazwick, Iwona, 'Uta Barth', *FRESH CREAM*, Phaidon Press, London, 2000

Bowen, Dore, 'RATTLE & ROLL. Rattling the Frame: The Photographic Space 1974–1999', *Afterimage*, Vol. 27, No. 5, Rochester, New York, March 2000

Brun, Donatella, 'Regards: Uta Barth', *Jardin des Modes*, Paris, Autumn 1995

Burton, Johanna, 'Uta Barth', *Time Out New York*, 7–14 November 2002

Campany, David, (ed.), *Art and Photography*, Phaidon Press, London, 2003

Clearwater, Bonnie, 'Slight of Hand: Photography in the 1990s', *Art Papers*, Atlanta, 1999

Conkelton, Sheryl, 'Uta Barth', *Journal of Contemporary Art*, Vol. 8, No. 1, New York, Summer 1997

Conkelton, Sheryl, 'Gound and Field, Before and After: Uta Barth in Conversation with Sheryl Conkelton' and 'In Between Places', *In Between Places*, Henry Art Gallery, University of Washington, Seattle/Distributed Art Publishers Inc., New York, 2000

Currah, Mark, 'Uta Barth, London Projects', *Time Out*, London, 14–21 October 1998

Decter, Joshua, 'Uta Barth at Tanya Bonakdar Gallery', *Artforum*, New York, April 1995

Diehl, Carol, 'Uta Barth at Bonakdar Jancou', *Art in America*, New York, October 1998

Exley, Roy, 'Uta Barth: London Projects', *Zing Magazine*, London, Winter 1998

Exley, Roy, 'New Abstract Photography: Towards Abstraction, the Painterly Photograph', *Creative Camera*, No. 358, London, June–July 1999

Ferguson, Russel, 'Into Thin Air', *In Between Places*, Henry Art Gallery, University of Washington, Seattle/Distributed Art Publishers Inc., New York, 2000

Fiskin, Judy, 'Trope l'Oeil for Our Time', *Art Issues*, No. 40, Los Angeles, November–December 1995

Folland, Tom, 'Uta Barth: S.L. Simpson Gallery', *Parachute*, No.86, Montreal, Spring 1997

French, David, 'Pick of the Week', *LA Weekly*, 17–23 May 1985

French, David, 'Uta Barth', *Visions: Art Quarterly, Visions 10*, Vol. 3, No.3, Los Angeles, Spring 1989

Gilbert-Rolfe, Jeremy, 'Cabbages, Raspberries and Video's Thin Brightness', *Art & Design, Painting in the Age of Artificial Intelligence*, Vol. 11, Nos. 5–6, London, May–June 1996

Gilbert-Rolfe, Jeremy, *Beauty and the Contemporary Sublime*, Allworth Press, London, 1999

Grabner, Michelle, 'Fuzzy Logic', *Cakewalk*, No. 1, Los Angeles, Spring–Summer 1998

Green, David A., 'Warm and Fuzzy: For Photographer Uta Barth, All the World's a Blur', *Los Angeles Reader*, 3 November 1995

Hagen, Charles, 'Review: Wooster Gardens', *New York Times*, 28 January 1994

Hapgood, Susan, 'Uta Barth at Tanya Bonakdar Gallery', *Art in America*, No. 5, New York, May 1995

Howe, Graham; Perez, Pilar, 'Portfolio 1991 – Southern California', *Frame/Work Magazine*, Vol 4., No. 3, Los Angeles Center for Photographic Studies 1991

Johnson, Patricia C., 'Uta Barth Focuses on Changing Perceptions', *Houston Chronicle*, 2001

Johnstone, Mark, *Contemporary Art in Southern California*, Craftsman House, 1999

Jones, Amelia, 'Uta Barth at domestic setting', *Art Issues*, No. 35, Los Angeles, November–December 1994

Jordan, Betty Ann, 'Uta Barth and Michael Snow at S.L. Simpson', *Globe*, Toronto, 2 November 1996

Kandel, Susan, 'Uta Barth', *Art and Text*, No. 52, Sydney, September 1995

Kandel, Susan, 'Pointed Images', *Los Angeles Times*, 27 June 1997

Keledjian, Chris, 'Ironies and Contradictions', *Artweek*, Palo Alto, 12 October 1985

Kertess, Klauss, *Photography Transhormed, The Metropolitan Mank and Trust Collection*, Harry N. Abrams, New York, 2002

Knight, Christopher, 'Art in All the Right Spaces', *Los Angeles Times*, 21 September 1995

Knode, Marilu, 'Uta Barth in Conversation with Marilu Knode', *Artlies Contemporary Art Magazine*, No. 7, June–July 1995

Kornbluth, Elena, 'Triple Exposure, Three Photographers in Focus, Sam Tayor-Wood, Uta Barth, Jessica Craig-Martin', *ELLE DÉCOR*, No. 81, New York, February–March 2001

Labelle, Charles, 'Uta Barth : ACME Gallery, Los Angeles', *Art & Text*, No. 68, Sydney, February–April 2000

Levin, Kim; Aletti, Vince, 'Our Biennial', *Village Voice*, New York, 21 January 1997

Lowery, Glen, 'Recontre Avec Uta Barth: Cham Libre', *Connaissance Des Arts*, No. 586, Paris, September 2001

Martegani, Micaela, 'Uta Barth: Tanya Bonakdar Gallery', *Tema Celete*, Milan, January–February 2003

Martin, Timothy, 'House and Extension', *... and of time*, self-published artist's book, 2000

Martin, Timothy, 'A Little Background Noise (Excerpts)', *In Between Places*, Henry Art Gallery, University of Washington, Seattle/Distributed Art Publishers Inc., New York, 2000

McGovern, Thomas, 'Uta Barth at ACME.', *Artweek*, Vol. 31, No. 1, Palo Alto, January 2000

Meyers, Holly, 'Loaded Questions amid the Treetops', *Los Angeles Times*, 25 October 2002

Munchnic, Suzanne, 'Uta Barth and Vikky Alexander', *ARTnews*, New York, November 1994

Nilsson, Håkan, 'Vardagens svit', *Dagens Nyheter*, Stockholm, 31 May 2003

Olofsson, Anders, 'Andréhn-Schiptjenko, Stockholm: Uta Barth (8/5 – 7/6)', www.konsten.net, May 2003

Pagel, David, 'Space Exploration', *Los Angeles Times*, 22 October 1999

Pagel, David, *CAArt: Themes Out of School*, Creative Artists Agency, The CAA Foundation, 2000

Pedrosa, Adriano, 'Uta Barth: Museum of Contemporary Art, Los Angeles', *frieze*, London, May 1996

Perchuk, Andrew, 'Uta Barth: Bonakdar Jancou Gallery', *Artforum*, New York, September 1998

Princenthal, Nancy, 'Uta Barth ... In Passing', *Art on Paper*, Vol. 1, No. 2, New York, November–December 1996

Rugoff, Ralph, 'Smear Tactics', *LA Weekly*, 20–26 October 1995

Schwendener, Martha, 'Uta Barth at Tanya Bonakdar Gallery', *New Art Examiner*, Chicago, April 1995

Scott, Michael, 'Backgrounds Come to the Fore', *Vancouver Sun*, 19 April 1997

Sheldon, Jim L., *Uta Barth: Photographs; Jane Calvin: Reflection, Recurrence – Rememory' Lorie Novak: Critiacal Distance*, Addison Gallery of American Art, Andover, Massachusetts, 1990

Smith, Elizabeth A.T., *At the Edge of the Decipherable: Recent Photographs by Uta Barth*, Museum of Contemporary Art, Los Angeles/RAM, Publications, 1995

Soo Jin Kim, 'Undoing Space', *Art & Design: Art & The Home*, No. 11, London, November–December 1996

Stament, Bill, 'Uta Barth, "Field #20" and "Field #21"', *Chicago Sun Times*, 25 June 1997

Sundell, Margaret, 'Uta Barth at Bonakdar Jancou', *Artforum*, New York, January 2000

Thrift, Julia, 'Uta Barth', *Time Out*, London, 15–24 July 1996

Tumlir, Jan, 'Uta Barth: ACME, Los Angeles', *Art & Text*, No. 62, Sydney, August–September 1998

Tumlir, Jan, 'to look, at nothing, with longing', *nowhere near*, self-published artist's book, 1999

Tumlir, Jan, *white blind (bright red)*, Site Santa Fe, 2004

Van de Walle, Mark, 'Uta Barth at Tanya Bonakdar', *Artforum*, New York, September 1996

Warner Marien, Mary, *Photography: A Cultural History*, Laurence King Publishing, London; Harry N. Abrams, New York, 2002

Watriss, Wendy, 'Uta Barth', *Blink: 100 Photographers, 010 Curators, 010 Writers*, Phaidon Press, London, 2002

Willette, Jeanne S.M., 'Reinventing Photography; "Photography as Commentary: The Camera (Obscura) and Post-Philosophical Systems"', *Artweek*, Vol. 28, No. 7, Palo Alto, July 1997

Wolf, Silvia, *Michael Rovner: The Space Between*, Whitney Museum of American Art, New York, 2002

Wolf, Silvio, 'Le Rangioni della Nuova: Fotofraphia Analogica', *Tema Celeste*, Milan, March–April 1997

Zellen, Jody, 'What Is a Geographical Space? Uta Barth: ACME., MoCA, Los Angeles', *artpress*, Paris, January 1996

Public Collections

Baltimore Museum of Art, Washington

Albright-Knox Art Gallery, Buffalo

LIST Visual Art Center at MIT, Cambridge, Massachusetts

Museum of Contemporary Art, Chicago

Museum of Contemporary Photography, Chicago

Weatherspoon Art Gallery, University of North Carolina, Greensboro, North Carolina

Dallas Museum of Art

Fornento Arte Contemporaneo, A.C., Guadalajara, Mexico

Museum of Fine Arts, Houston

Israel Museum, Jerusalem

Tate Gallery, London

Gruenwald Center, Los Angeles, California

J. Paul Getty Museum, Los Angeles

Los Angeles Center for Photographic Studies

Los Angeles County Museum of Art

Museum of Contemporary Art, Los Angeles

The Museum of Art, Rhode Island School of Design, Providence

Jumex Foundation Museum, Mexico City

Miami Art Museum, Miami

Museum of Contemporary Art, Miami

Orange County Museum of Art, Newport Beach, California

Metropolitan Museum of Art, New York

Solomon R. Guggenheim Museum, New York

The Museum of Modern Art, New York, New York

Whitney Museum of American Art, New York

Ohio University Museum

Princeton Art Museum, New Jersey

Lannan Foundation, Santa Fe

Henry Art Gallery, Seattle, Washington

San Diego Museum of Art, California

San Francisco Museum of Modern Art

Seattle Art Museum, Washington

Joseph Monsen Collection, Seattle, Washington

Magazin 3 Stockholm Konsthall

Worchester Museum, Massachusetts

Comparative Images

page 106, **Ansel Adams**
Moon and Mount McKinley, Denali National Park

page 85, **Bas Jan Ader**
I'm Too Sad to Tell You
Museum Boymans van Beuningen, Rotterdam

page 79, **Michelangelo Antonioni**
Blow-Up

page 102, **Michelangelo Antonioni**
The Red Desert

page 57, **Julia Margaret Cameron**
Annie: My First Success

page 85, **Jan Dibbets**
12 Hour Tide Objects with Correction of perspective

page 106, **Andreas Gursky**
99 Cent

page 12, **Robert Irwin**
Untitled
Walker Art Center, Minneapolis, Minnesota

page 12, **Barbara Kruger**
We Are the Objects of Your Suave Entrapment

page 12, **Sherrie Levine**
Untitled (After Walker Evans No. 3)
Metropolitan Museum of Art, New York

page 106, **Timothy O'Sullivan**
Sand Dunes, Carson Desert

page 124, **Gerhard Richter**
Record Player (from the series October 18, 1977)
The Museum of Modern Art, New York

page 58, **Georges Seurat**
Quai (Gravelines un soir)

page 85, **Michael Snow**
Wavelength

page 57, **Alfred Stieglitz**
Equivalent
National Gallery of Art, Washington, DC

page 130, **Jan Vermeer**
The Milkmaid
Rijksmuseum, Amsterdam

List of Illustrated Works

page 22, **... and of time. (aot 1)**, 2000

pages 24–25, **... and of time. (aot 2)**, 2000

page 23, **... and of time. (aot 4)**, 2000

page 16, **as**, 1994

page 70, **Field #2**, 1995

page 72, **Field #3**, 1995

page 126, **Field #5**, 1995

page 127, **Field #6**, 1995

page 128, **Field #7**, 1995

page 132, **Field #8**, 1995

page 97, **Field #9**, 1995

pages 74–75, **Field #14**, 1996

page 70, **Field #17**, 1996

page 77, **Field #20**, 1995

page 76, **Field #21**, 1997

page 44, **Ground #1**, 1992

page 45, **Ground #2**, 1992–93

page 47, **Ground #3**, 1992

page 44, **Ground #4**, 1992–93

page 19, **Ground #9**, 1992–93

page 18, **Ground #12**, 1992–93

page 48, **Ground #13**, 1992–93

page 48, **Ground #21**, 1992

page 131, **Ground #30**, 1994

page 50, **Ground #36**, 1994

page 52, **Ground #38**, 1994

page 61, **Ground #40**, 1994

page 55, **Ground #41**, 1994

page 9, **Ground #42**, 1994

page 58, **Ground #43**, 1994

page 54, **Ground #44**, 1994

page 53, **Ground #45**, 1994

page 62, **Ground #46**, 1994

page 63, **Ground #47**, 1994

page 64, **Ground #51**, 1995

page 56, **Ground #52**, 1995

page 65, **Ground #53**, 1995

page 67, **Ground #56**, 1995

page 66, **Ground #59**, 1995

page 66, **Ground #60**, 1995

page 49, **Ground #66**, 1996

page 32, **Ground #70**, 1996

page 110, **Ground #77**, 1997

page 51, **Ground #78**, 1997

page 134, **Ground #96.1**, 1996

page 134, **Ground #96.2**, 1996

page 135, **Ground #96.3**, 1996

page 17, **if**, 1994

pages 113, 114, 116–17, 118, **... in passing**, 1996

pages 82–83, **nowhere near (nw 1)**, 1999

page 87, **nowhere near (nw 4)**, 1999

pages 86–87, **nowhere near (nw 7)**, 1999

page 21, **nowhere near (nw 9)**, 1999

page 20, **nowhere near (nw 10)**, 1999

page 80, **nowhere near (nw 11)**, 1999

page 84, **nowhere near (nw 12)**, 1999

pages 88–89, **nowhere near (nw 14)**, 1999

page 91, **nowhere near (nw 15)**, 1999

page 81, **nowhere near (nw 17)**, 1999

page 90, **nowhere near (nw 19)**, 1999

page 73, **Untitled**, 1992

page 13, **Untitled #1**, 1989

page 14, **Untitled #8**, 1989

page 4, **Untitled #8**, 1990

page 42, **Untitled #13**, 1991

page 39, **Untitled #14**, 1990

page 15, **Untitled #14**, 1991

page 40, **Untitled #16**, 1990

pages 28–29, **Untitled (98.1)**, 1998

page 26, **Untitled (98.2)**, 1998

page 78, **Untitled (98.4)**, 1998

pages 100, 103, 104–05, 109 **Untitled (98.5)**, 1998

page 79, **Untitled (98.6)**, 1998

pages 98–99, **Untitled (98.11)**, 1998

page 27, **Untitled (99.1)**, 1999

pages 30–31, 32–33, 36–37, 92, 94, 136–37, 138–39, 140–141, 142–43 **white blind (bright red)**, 2002